Easy Design Techniques
for
Porcelain

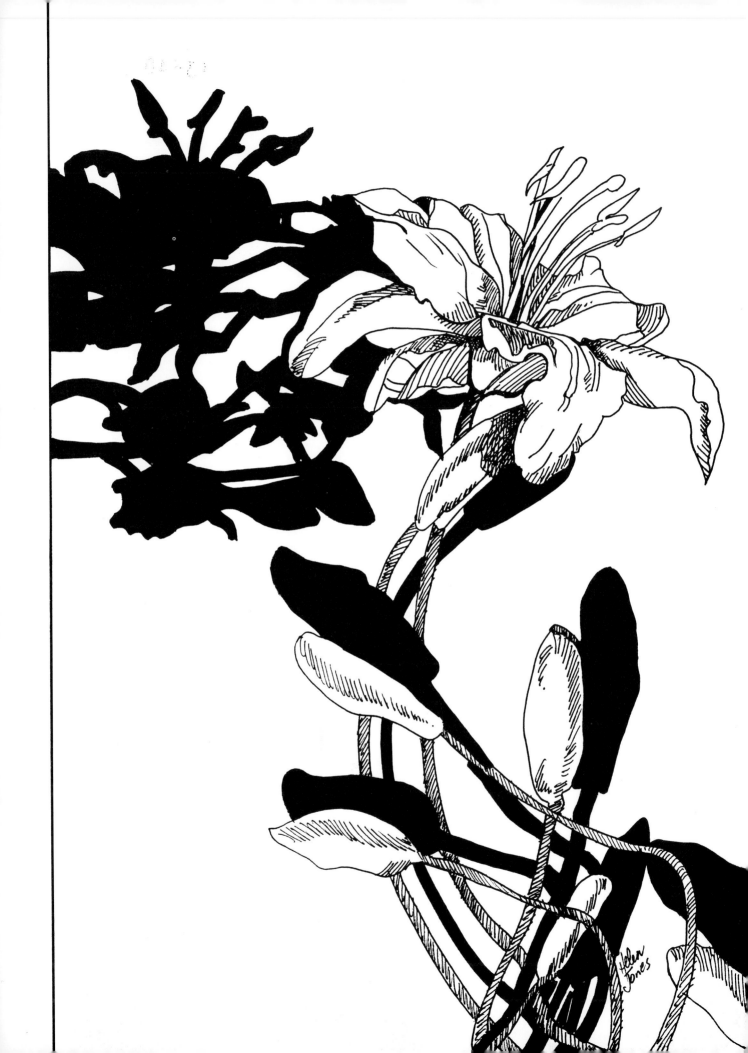

Easy Design Techniques
for
Porcelain

Heather Tailor and Helen Jones

Kangaroo Press

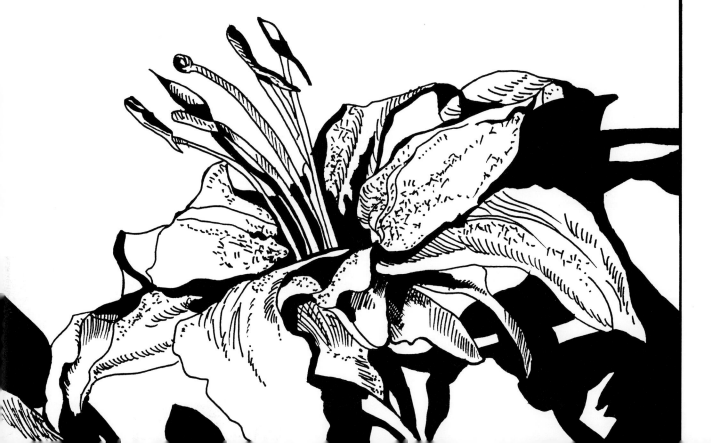

Acknowledgments

Dedicated to all our peers who believe in contemporary onglaze . . . they will know who.

All the designs, drawings and paintings are the work of Helen Jones and Heather Tailor and were prepared especially for this publication.

The photography is by Heather Tailor unless otherwise acknowledged.

First published in 1993 by Kangaroo Press Pty Ltd
3 Whitehall Road Kenthurst NSW 2156 Australia
P.O. Box 6125 Dural Delivery Centre NSW 2158 Australia
Typeset by G.T. Setters Pty Limited
Printed by Toppan Singapore

ISBN 0 86417 531 0

CONTENTS

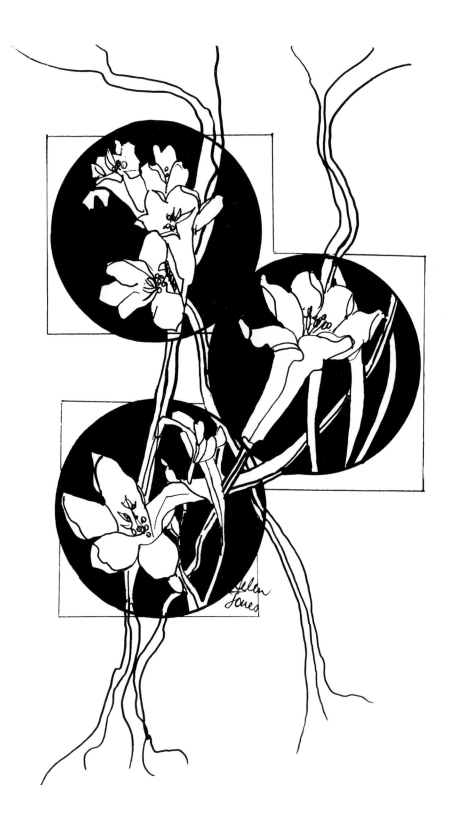

PREFACE

Decorative artists working on porcelain, ceramic, fabric, glass, leather, wood and paper must be competent not only in drawing and design but in the technical skills related to their craft. In many cases technical proficiency takes precedence over design preparation but this is understandable, as many hours of practice are required to master some of the more complicated techniques of onglaze painting and other decorative art forms.

Many decorative artists depend on pictures and motifs copied from books and magazines, or on random accidental effects, for their artwork. Some are unable or unwilling to spend any time creating their own designs. During the many years we have taught art at tertiary diploma level, and in private studios and schools, we have found that decorative artists in general have excellent technical skills but poor design and drawing abilities. Many expect their tutor to provide a design for copying.

In college courses design and drawing units are compulsory, but attempts to incorporate a mandatory design element into private classes are often unsuccessful. Most students enrol to learn technical skills and are reluctant to spend valuable lesson time on drawing and design instruction. They leap in and do the painting without any preparation, either hoping for the best or expecting their tutor to correct the mistakes.

Our objective in writing this book is to demonstrate to china painters and decorative artists our method of creating designs. Many readers will be content to adapt the photographs and ideas and to copy the designs for their own purposes, but we hope that among the many skilled artists there are some who will find our approach helpful in the creation of their own designs.

Flowers are the easiest subject to stylise and abstract, as they are flexible, colourful and easy to photograph, and adapt to any surface or technique. There is a long tradition of flower and plant design in the decorative arts—for instance, the Art Nouveau movement was based on the simplicity of nature.

Good design depends on preparation and planning, which begins with observation and research. Photography can play a useful role in this first stage, accurately recording the shapes, colours and textures of plants and flowers.

Sketching the subject is essential if one is to become familiar with the shapes and lines, growth pattern and attitude of the plant. The sketches can then be stylised and abstracted; from these drawings an infinite variety of designs can be developed, as we show in this book.

Drawing and design train the eye to see and appreciate the principles and elements of design, to better judge the quality of spontaneous self-expression and to understand what is needed to rectify a mistake. The most successful pieces depend on good design planning, a thorough knowledge of techniques and the ability to relate those techniques to the design. This book is dedicated to easy design methods and shows examples of finished art pieces. Brief instructions for each figure appear in Chapter 12. For tuition on china painting techniques we refer you to three previous Kangaroo Press publications, *Lustre for China Painters and Potters* and *Easy Onglaze Techniques for China Painters and Potters*, both by Heather Tailor, and *Textures and Techniques for Porcelain and Ceramics* by Sandra Brown.

There are very few shortcuts in art. Often it seems like travelling miles to move inches but we believe that it's the journey that's important. Once embarked on a challenging artistic adventure a whole new world of ideas opens up, one design leading to another.

Heather Tailor and Helen Jones, 1993

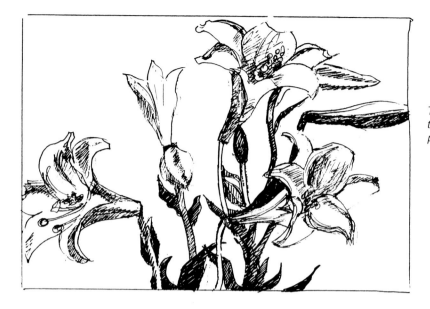

This lily has been drawn as accurately as possible to be used as a starting point for the design process

CHAPTER **1**

EASY DESIGN PROCESSES

Stylising is a method employing slight abstraction; shapes can be exaggerated by making them more angular

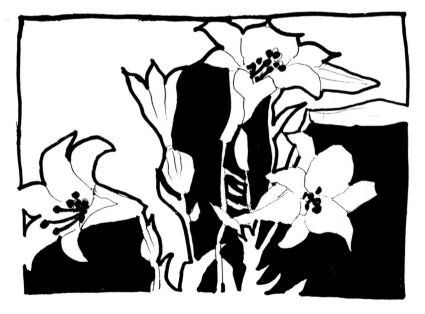

Contrast can be achieved by filling in some of the spaces; these negative shapes become stepping stones for movement across the composition

One of the most important facets of the design process in any art or craft form is finding and interpreting sources and inspirations for design—in other words, the thinking process.

Although chance and accident are also part of art, in all aspects of applied and decorative art the planning and understanding of both the problem and the techniques are necessary so that the desired effect will be achieved.

Many of the designs in this publication are aimed at the art of onglaze painting, therefore there are references to techniques appropriate to this art. However, the same process can be used to create designs for textiles, jewellery, stained glass, leather, embroidery, stencilling and other decorative arts and crafts.

You need to ask some questions before you start:
• What is to be achieved?
• What specific visual and/or intellectual effect is required?
• What style will achieve this effect—realistic, stylised or abstracted?
• What are the physical and technical limitations of the china or other medium selected? For example, size, shape, colour schemes, combination of techniques and firing requirements?

Time spent considering the above questions will result in fewer unexpected happenings—not to mention complete failures!

Elements and principles of design

Think about the elements of design—shape, size, proportion, colour, line, value and texture—and about how best to utilise both the potential of the medium itself and the enormous amount of techniques available to you. Design principles *can be learned*, especially from the many excellent design texts available on the subject.

Sources of designs

Inspiration from many sources is available to you—especially from nature, which is the richest area. But you must be most observant, and *see* the essence and character of the stimulus, to fully explore and interpret the design process for individual works. The photographs and drawings from nature in the following chapters show you how this can be achieved.

Design processes

Within each chapter the subject has been followed through from the photograph of the original flower to a realistic line drawing to stylised, non-objective designs. Examples of the design processes are shown on page 13.

Briefly, the procedures are as follows:

1. Realistic drawing
These illustrations have been drawn as accurately as possible showing tonal values, and are the starting point for the design processes following. The photographs also provide stimulus for colour schemes.

2. Stylising
Stylising is a design method employing slight, generalised abstraction; it omits some detail from the realistic drawing, specifically in the tonal areas. Lines and shapes can be exaggerated by making them more strongly curved or angled.

3. Negative and positive space
Contrast can be achieved by filling in some of the spaces. The negative and positive shapes so created can become stepping stones for movement and direction across the composition.

4. Line extension
On designs drawn following the principles in 1–3, line extension and line elaboration can be employed to break up the background space into more exciting and interesting visual effects. The lines are an extension of the subject itself and must flow naturally.

Line extension can be employed to break up the background space into more interesting visual areas

5. Open frame
Open frame is similar to capturing just a section of the
subject, leaving the imagination to fill in the gaps beyond
the border.

6. Broken frame
This type of composition is similar to open frame, but breaks
through the borders of the field in certain areas to produce
exciting visual happenings. When used with double frames
and borders it heightens the dynamics of the finished piece.

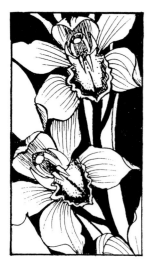

*Open frame is similar to
capturing just a section of the
subject, leaving the imagination
to fill in the gaps beyond the
border*

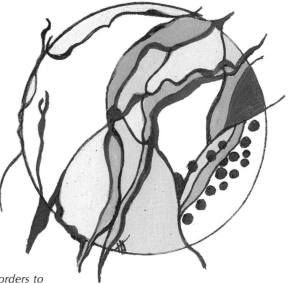

*Broken frame composition 'breaks through' the borders to
produce exciting visual effects*

7. Pattern using repetition
Motifs or units taken from small or large areas of the
drawings can be repeated by touching or superimposing to
achieve an all-over pattern, borders or panels. Some of the
patterns are random, others can be symmetrically arranged.
Motifs can be reversed, turned upside down, or used in any
way you like to create the desired result.

*Motifs or units taken from areas of the
drawings can be repeated to create
borders or panels*

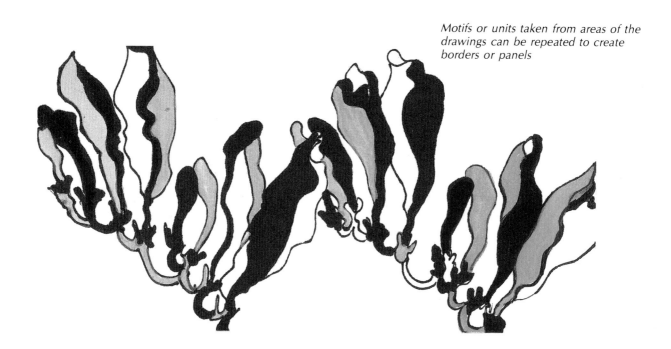

10

8. Distortion

Distortion can be achieved by many methods including cutting and rearranging, or by creating a field and distorting the image to fit as is common in Art Nouveau designs.

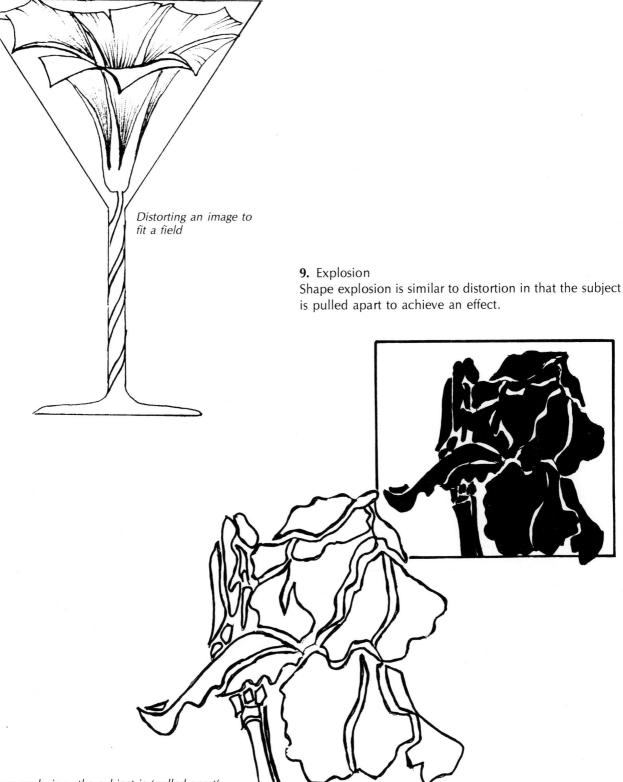

Distorting an image to fit a field

9. Explosion

Shape explosion is similar to distortion in that the subject is pulled apart to achieve an effect.

Shape explosion—the subject is 'pulled apart'

10. Cropping (close-up)

Cropping is used to find small balanced areas in the overall design. The cropped areas may be cut out and used for small design work, or enlarged to create pure abstract (non-objective) images. In this method details are ignored as the shapes are reduced to their simplest forms.

'Cropping' is finding small areas in the design which may be cut out and used for small design work. The abstract designs in this book have been achieved by moving a viewfinder over the naturalistic and stylised drawings. These croppings become non-objective but should be attractive as visual patterns

Non-objective abstraction Abstraction is not a new technique. Primitive art often shows abstract forms. Non-objective art forces us to appreciate the works as visual patterns— not as story-telling narratives but solely as visual designs. The lack of subject matter does not, however, always eliminate the emotional content in the image.

The abstract designs in this book have been achieved with the use of viewfinders (described in detail and illustrated in Chapter 2). These are moved over the drawings or the stylised designs until a pleasing section is located. When enlarged these croppings can become non-objective but should always be attractive as a visual pattern.

11. Geometric cropping

Cropping is used again but in this method the lines and shapes of the cropped design are reworked and angled to create a geometric image. This type of design is frequently appropriate for functional and contemporary pieces.

12. Organic cropping

The basic cropping technique is used again to choose the most appropriate area of the design, but here the lines and shapes are reworked to become curvilinear and organic, creating gentle flowing designs of infinite variety.

Summary

All these types of design can be used on any shape or surface. Each individual painter, with planning and the use of methodical design processes, can create many varied pieces of decorative art. The suggestions in this book are only offered as a starting point for your own work. As you gain in confidence, as you practice and reach a greater understanding of the design principles, you can explore your own personal design ideas to develop your own style and individuality.

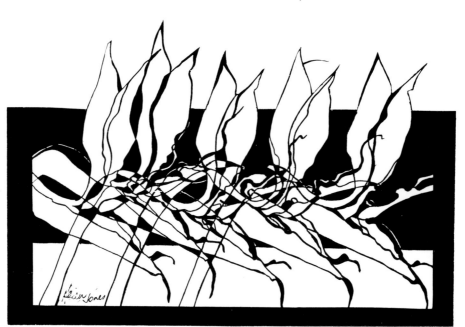

Examples of design processes

Realistic

Stylised

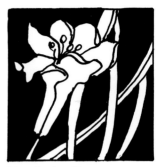

Negative/positive space

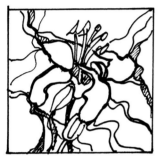

Line extension

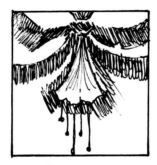

Open frame

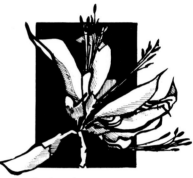

Broken frame

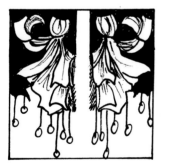

Repetition

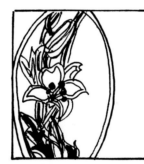

Distortion

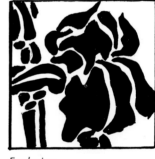

Explosion

Cropping—close-up

*Geometric cropping
(non-objective)*

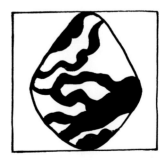

*Organic cropping
(non-objective)*

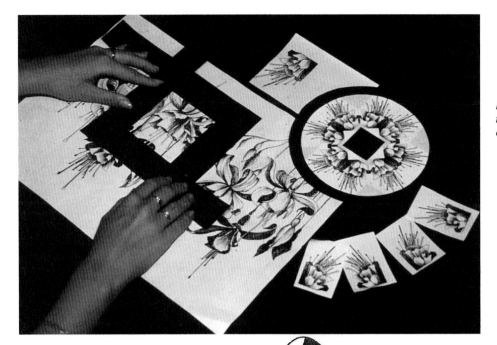

Framing up interesting design areas from the master drawing using a pair of L-shaped viewfinders

The photocopier will enlarge and reduce designs

CHAPTER 2

TOOLS FOR THE DESIGNER

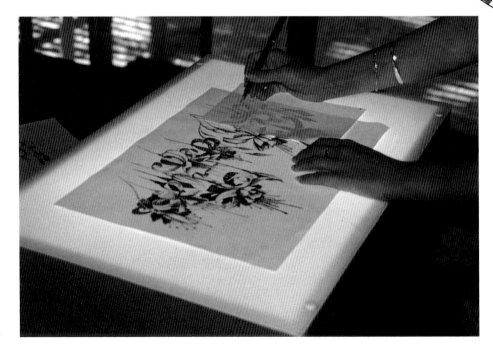

The light box produces a soft diffused light, strong enough to project through several sheets of paper

The first sketch toward a design should be made on litho or design paper using a 2B pencil and a soft plastic eraser for corrections. Design or layout paper has a smooth surface while litho paper is shiny on one side and matte on the other; both are available in sheets or pads.

Once the basic sketch is complete the design lines are carefully reworked with a fine-tipped black marker pen such as an Artline 200 (0.4), and the solid areas filled in with a thicker marker. Calligraphy markers are also useful for drawing wide lines from 1 mm to 5 mm in thickness.

Corrections to the black areas are made with white correction fluid available with a dip-in brush applicator or as a pen.

A transparent plastic ruler is useful for drawing frames around and within the design, and a compass for drawing circles. (Any circular object of the appropriate size can act as a template if you don't have a compass.) Curved shapes can be drawn with the aid of a flexible curve, a thick plastic strip which will bend in any direction and is available from art shops.

Viewfinder

To frame up and crop out interesting design areas from the master drawing, make a pair of L-shaped viewfinders from black or white lightweight cardboard.

The viewfinder should be made in a size relevant to the designs. A pair of L shapes 20 cm × 20 cm × 4 cm wide can be manipulated to frame up a square or rectangular design in any size from a few millimetres to 20 cm across.

Light table

Only a certain amount of work can be done on the original drawing before parts of the design will need tracing off for further development.

By placing the original copy onto a sheet of glass, placing a fresh sheet of paper over the drawing and positioning the glass over a light source, the lines of the design will be clearly projected through both sheets of paper so that parts of the design can be traced onto the new page. A well lit window or a sheet of glass held over a lamp will provide enough light to trace over.

The ideal piece of tracing equipment is a light table (or light box) which can be made by placing a fluorescent lamp inside a box and covering the top with a sheet of rigid white acrylic. This produces a soft diffused light which is strong enough to project through several sheets of paper without the glare of a naked light globe.

The light box illustrated is constructed of 16 mm medium density fibre board, the base 640 mm long and 430 mm wide and the sides 170 mm high, with a 620 mm fluorescent lamp laid across the bottom and screwed into place. A hole was drilled in an end panel for the electric cord to pass through, and several holes drilled in the bottom to disperse the heat from the lamp. The inside of the box was painted white to reflect more light; small rubber stoppers were fitted to the base to elevate it slightly to allow heat dissipation, and to stop the box from sliding. The top is a solid sheet of 3 mm opal acrylic from a company supplying plastic materials. Holes were drilled around the edge of the acrylic and the top screwed down to the base. The box is light weight for easy handling and cost approximately A$50.

Professionally made light boxes and tables are available from graphic design suppliers.

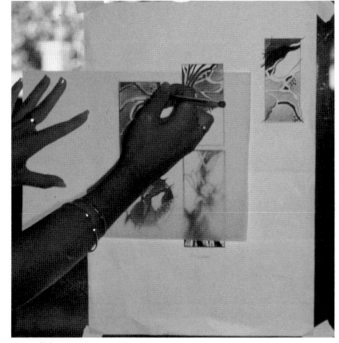

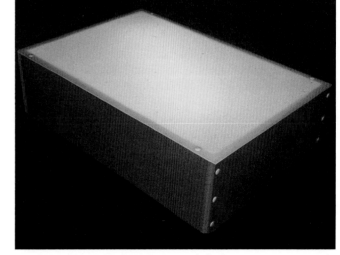

A well-lit window will provide enough light to trace by, but the ideal piece of tracing equipment is a light box

Photocopier

Access to a photocopier will make drawing and design development much easier, especially if the photocopier has enlargement and reduction capabilities.

Prints of original plant material can be made by laying pieces directly onto the glass of the copier. These black and white tonal silhouettes will help in the preparation of realistic drawings.

The best results come from thin, light coloured plant material, as the copier can only reproduce a few light tones. Thick dark pieces generally give disappointing results as the darker values reproduce quite black. Experiment with the tonal control on the copier and try making lighter copies when the picture is too dark.

Some plant material is so bulky that the lid of the copier will not close. In this case leave the lid up and lay a piece of densely woven dark fabric over the top of the machine to block out the light. Care should be taken not to scratch the glass or leave stains on it—it is advisable to ask the owner's permission before attempting to squash flowers under the lid!

During the design development process multiple copies of the drawings and designs can be used for experimentation; enlarged copies will often reveal interesting new dimensions.

Small areas can be enlarged, large designs reduced and parts of the designs cut out and repositioned (cut and paste) to make new compositions and repetitive sequences. A glue stick is ideal for this type of quick paste-up work.

The designs in this book may also be photocopied, enlarged or reduced and adapted for different surfaces.

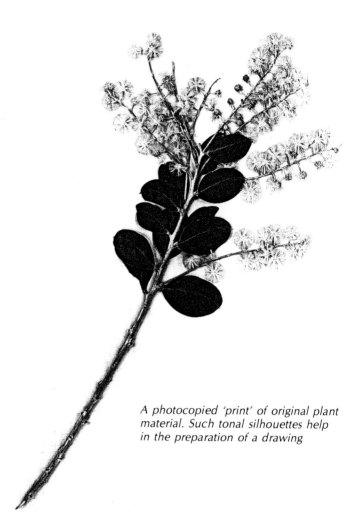

A photocopied 'print' of original plant material. Such tonal silhouettes help in the preparation of a drawing

Coloured media

Whether the design you are working on is intended for a porcelain, glass, fabric or wood surface, give some thought early on to the colour scheme. Make several copies of the design to use purely for colour experimentation.

Coloured pencils are a very quick and easy way to block in areas of colour. As an alternative, water-soluble pencils produce both linear shading and solid colour when brushed with water.

Felt-tipped coloured markers produce bright solid colours, while the more sophisticated brush pens are available in a larger range of tones.

Waterbased paint is preferable for colour experimentation because values and shades can be mixed and adjusted more accurately. When waterbased materials are to be used it is best to trace the design onto cartridge paper or smooth (hot pressed) watercolour paper for more accurate results.

The ultimate colour medium for designers is gouache, a thick opaque waterbased paint supplied in tubes and available in a wide range of hues as well as in the metallic colours gold, silver and bronze. Gouache should be mixed with a little water into a thick creamy paint and applied smoothly with a sable or synthetic brush—a pointed brush for line work and a flat brush for solid areas. Unlike watercolour, gouache is not transparent. Tints are made by adding white to the colour and it is possible to create an enormous range of rich, fully saturated hues, tints, tones, neutrals and greys.

Transferring the design

Once the planning and experimental stage is complete, the design outline is ready to be transferred to the article for decoration. The design can be traced onto transparent tracing paper first using a black marker pen. Soft pencil is scribbled onto the back and the tracing then taped into place on the surface of the article. A ballpoint pen or stylus is used to retrace the design, pressing the pencil marks from the back of the paper onto the surface. The advantages of using tracing paper are that the surface can be seen

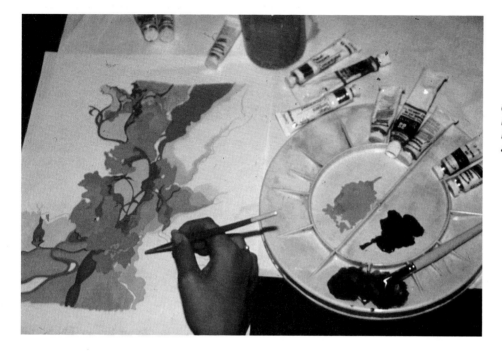

through the paper and that the image is easily reversed.

A number of carbon and graphite transfer papers are available in black, white and various colours. This thin film is slipped in between the surface of the article to be decorated and the drawing, tracing or photocopy, and held in place with either tape or reusable adhesive. A stylus is used to retrace the design, pressing a carbon imprint of the image onto the surface.

Shaped surfaces are often difficult to transfer a design onto as the paper will not mould around the shape. Try trimming the tracing down by cutting the excess paper away with scissors and making slits or short cuts in the paper to bring the tracing into contact with the surface.

Where multiple images are required from one tracing, make a compact template by attaching a piece of carbon paper to the underside of the tracing; then it can be positioned, traced, lifted and repositioned quickly.

Large simple shapes can be transferred onto a surface by cutting the shape out with scissors and using it as a template to draw around. Hold the template in place either with tape or a reusable adhesive such as Blu-tack.

Unfortunately there is no quick way of transferring a design from paper onto a surface unless it can be hand drawn directly. When a designer works on a particular subject for some time the shape and style of the design can become so familiar that it is possible to hand draw the design onto a surface and make the necessary modifications to fit different shapes at the same time.

The design has been traced onto tracing paper and a sheet of graphite paper placed between the tracing and the plate. A stylus is being used to retrace the design

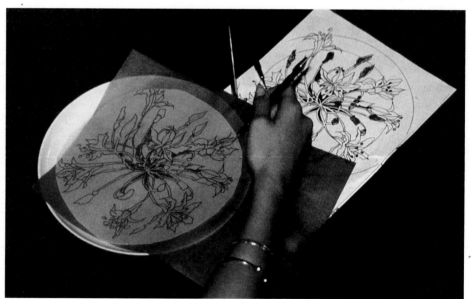

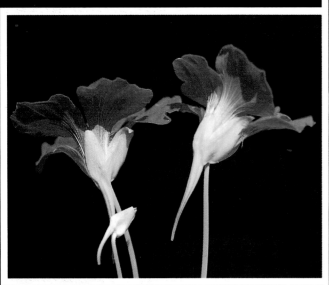

CHAPTER 3

NASTURTIUMS

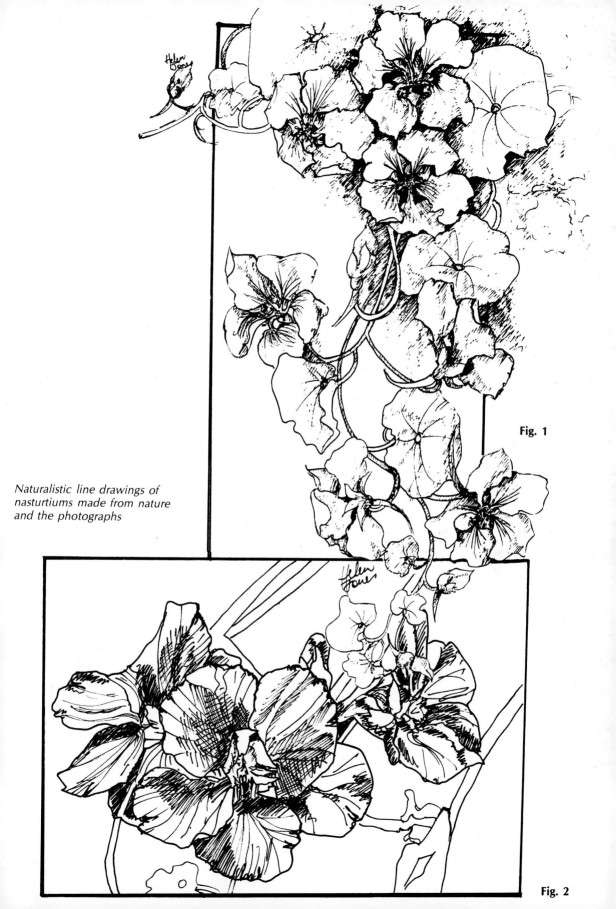

Naturalistic line drawings of nasturtiums made from nature and the photographs

Fig. 1

Fig. 2

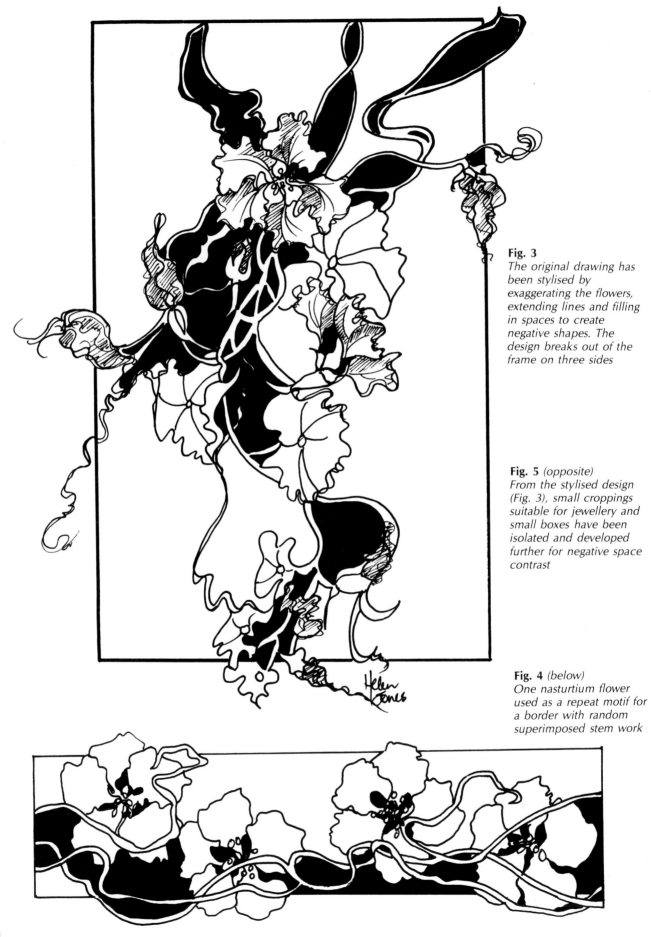

Fig. 3
The original drawing has been stylised by exaggerating the flowers, extending lines and filling in spaces to create negative shapes. The design breaks out of the frame on three sides

Fig. 5 *(opposite)*
From the stylised design (Fig. 3), small croppings suitable for jewellery and small boxes have been isolated and developed further for negative space contrast

Fig. 4 *(below)*
One nasturtium flower used as a repeat motif for a border with random superimposed stem work

20

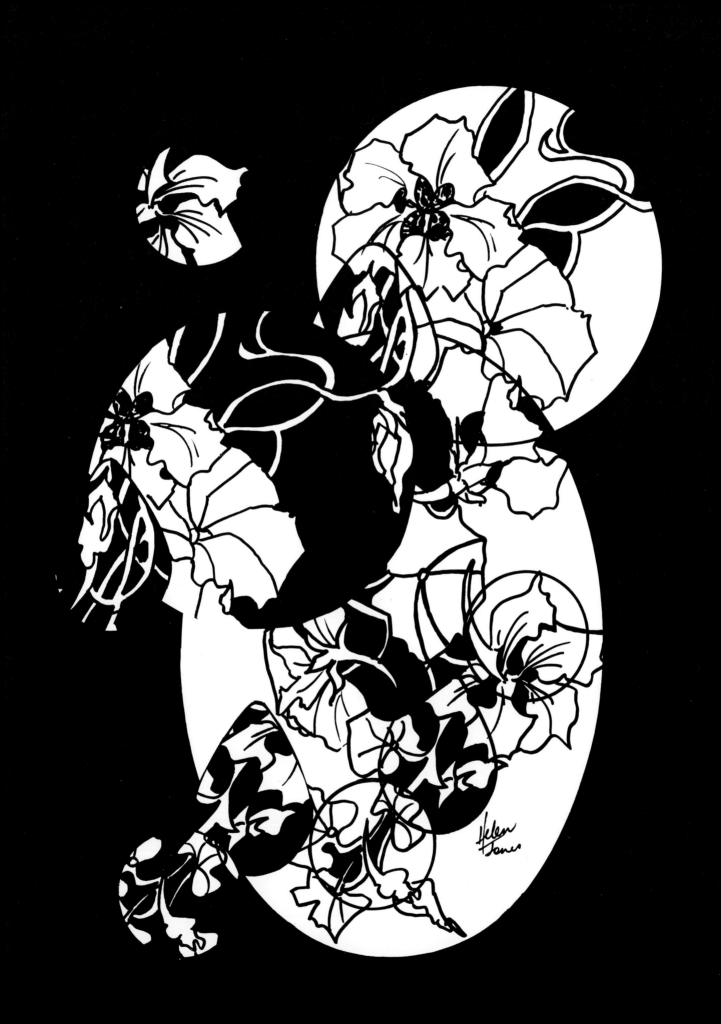

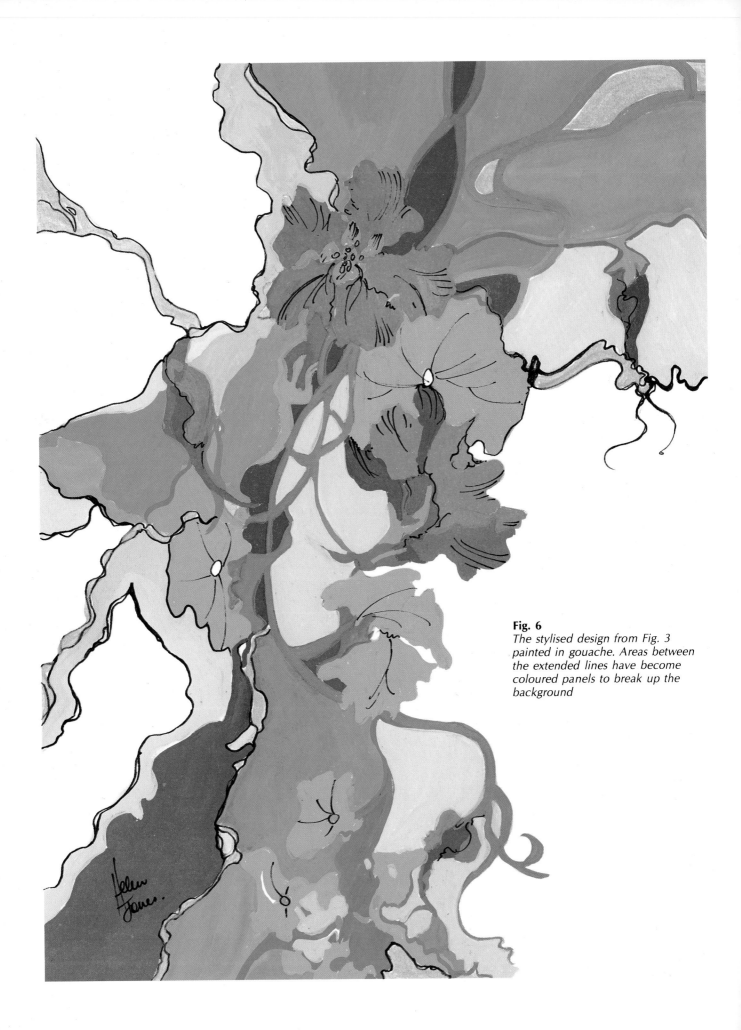

Fig. 6
*The stylised design from Fig. 3
painted in gouache. Areas between
the extended lines have become
coloured panels to break up the
background*

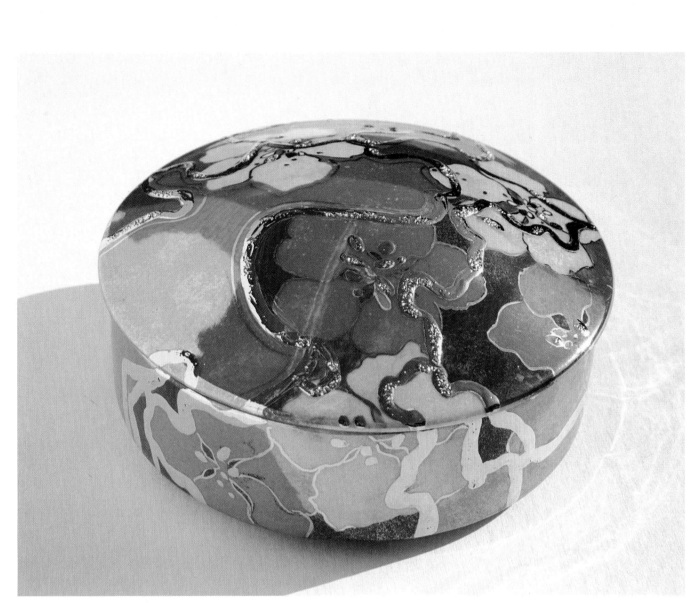

Fig. 3.1
Helen Jones: 'Nasturtiums'—The design for this 17 cm box has been adapted from Fig. 4 and painted in lustre and raised gold work. Instructions page 81

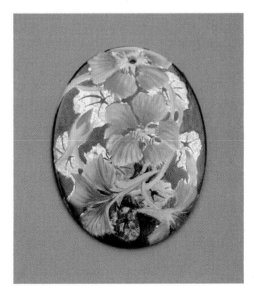

Fig. 3.2
Heather Tailor: 'Nasturtium pendant' (6 cm × 4 cm)— The pendant features marbelised gold leaves on a black background. The design is adapted from Fig. 1. Instructions page 81

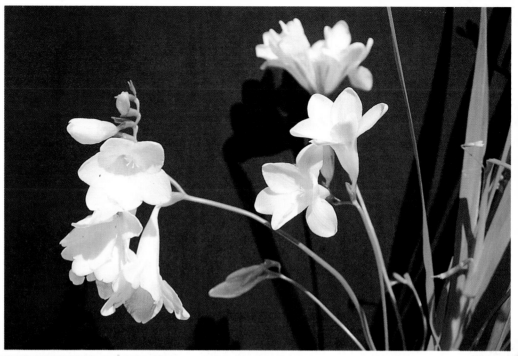

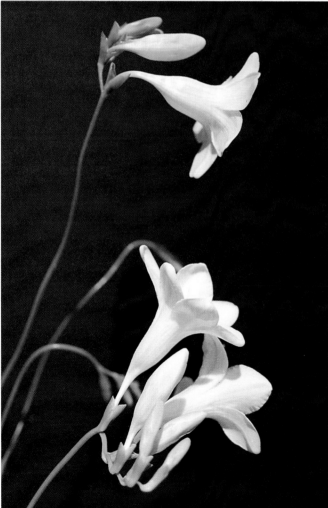

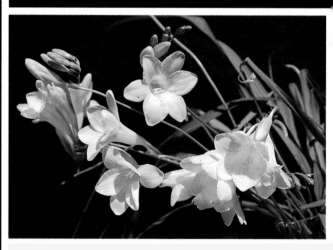

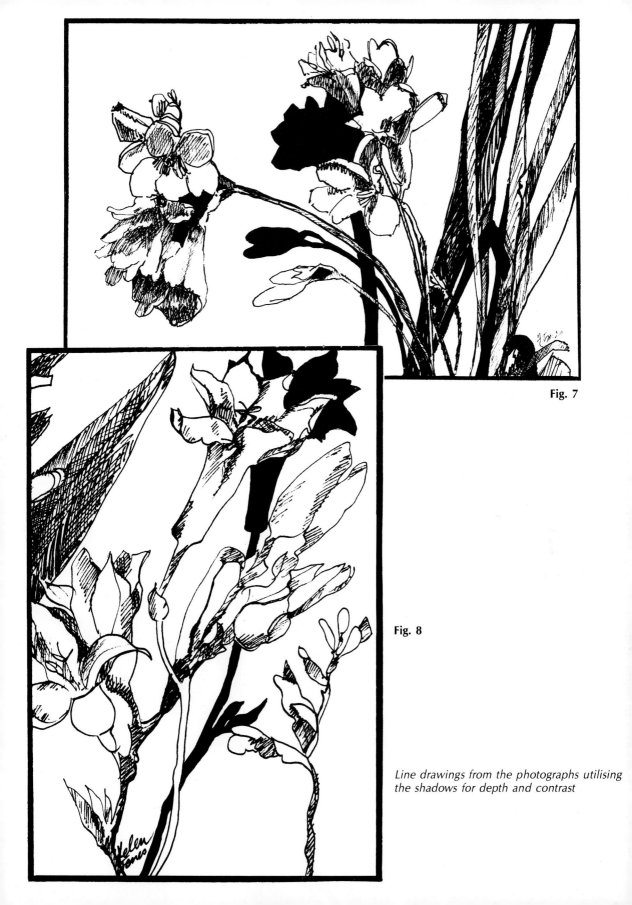

Fig. 7

Fig. 8

Line drawings from the photographs utilising the shadows for depth and contrast

Fig. 9
*The freesias have been slightly abstracted;
lines extend diagonally to create movement
and direction. By filling in some of the
negative space, dark panels create dynamic
contrast*

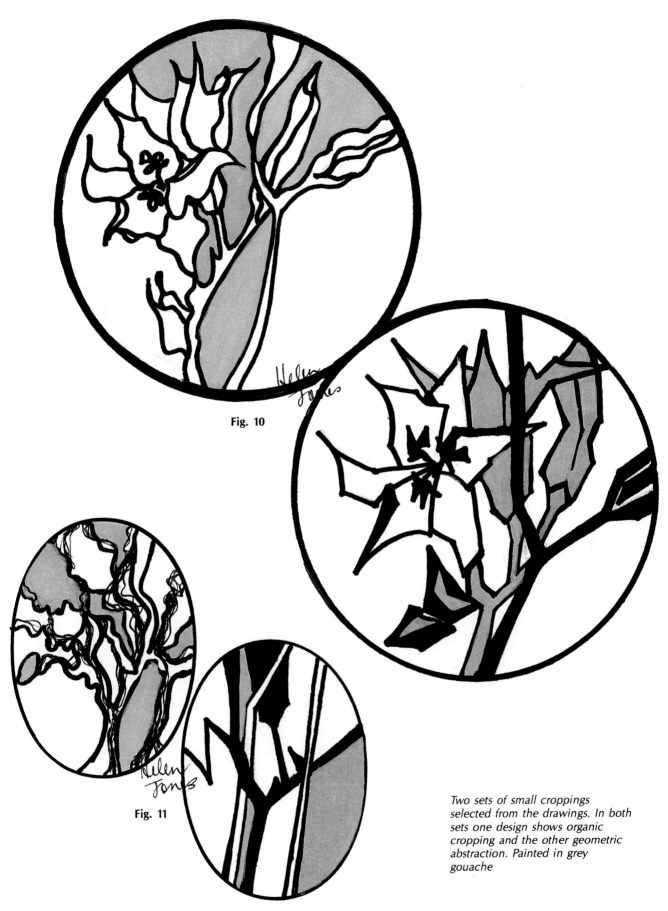

Fig. 10

Fig. 11

Two sets of small croppings
selected from the drawings. In both
sets one design shows organic
cropping and the other geometric
abstraction. Painted in grey
gouache

Fig. 12
An abstracted section from Fig. 7 with line and dot elaboration

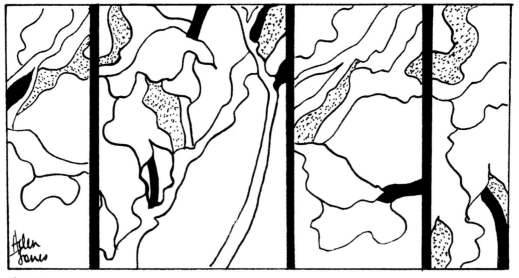

Fig. 13
Abstracted sections from Fig. 12 creating a panel design

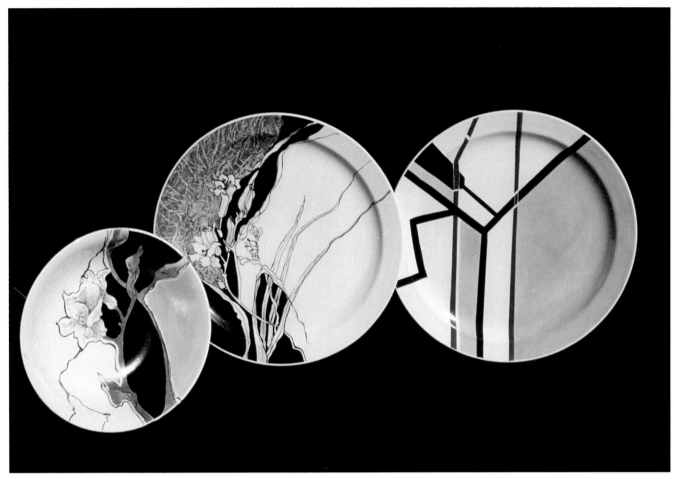

Fig. 4.1
Three pieces of functional ware by Helen Jones. Each shows how the freesia design has been adapted to allow the maximum decorative effect with the minimum of firings. Platters 32 cm. Bowl 23 cm. Instructions page 82

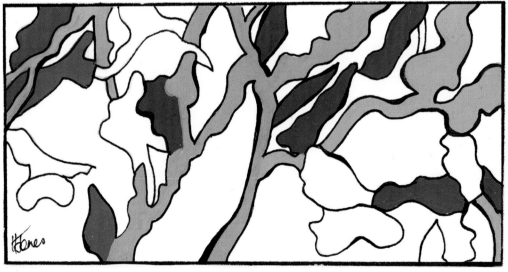

Fig. 4.2
An abstract freesia design based on Figs. 12 and 13, painted in gouache by Helen Jones as a colour experiment

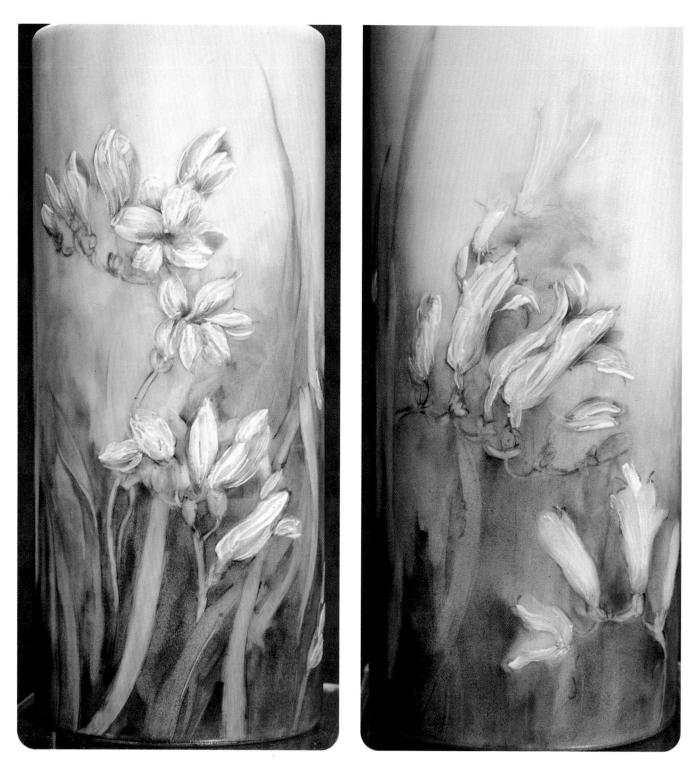

Fig. 4.3
Front and back views of a 25 cm porcelain cylinder vase by Helen Jones. The freesias are painted in naturalistic brushwork using light washes to build up the colour and tonal values. The flowers are highlighted with white texture coat. Instructions page 82

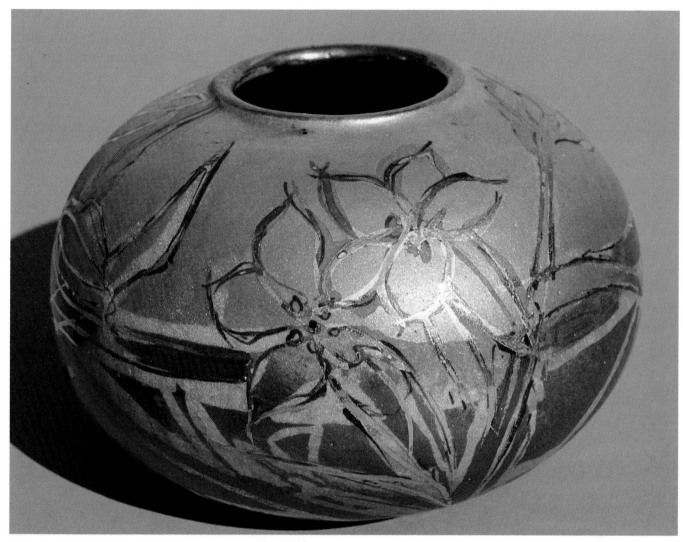

Fig. 4.4
Helen Jones: 'Freesias' (18 cm glazed terracotta vase)—Painted with metallics and gold in a free gestural style in keeping with the earthy pot. Instructions page 82

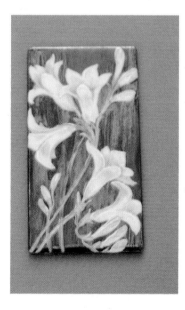

Fig. 4.5
Heather Tailor: 'Freesia pin' (7 cm)—Texture coat was used to whiten the flowers against an iridescent black background. Inspired by the freesia photographs. Instructions page 82

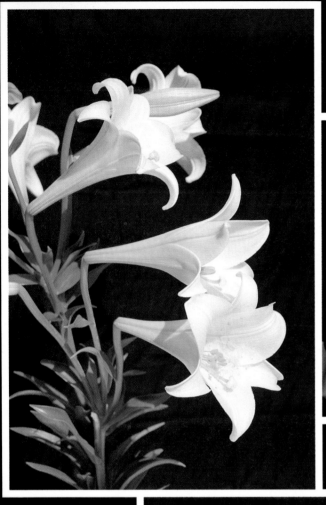

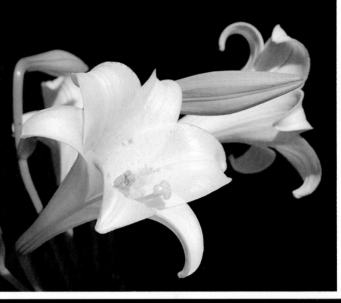

CHAPTER **5**

LILIES

NOVEMBER
LILIES

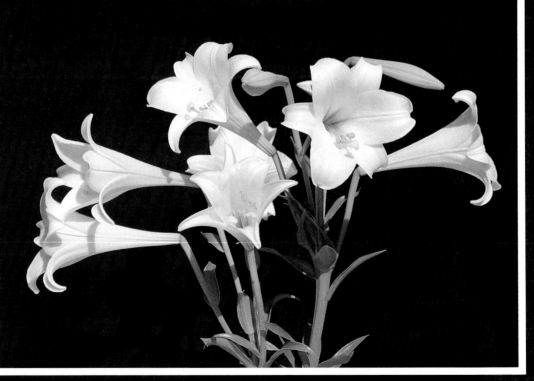

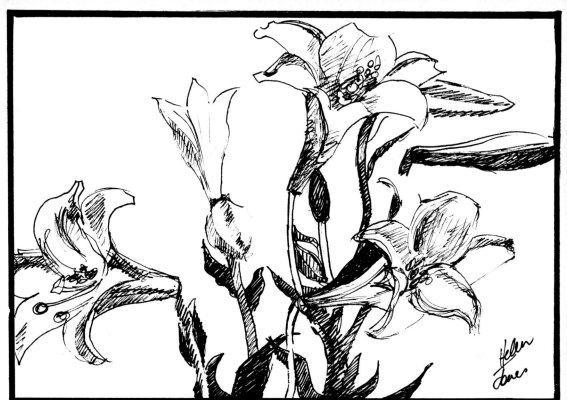

Fig. 14
A naturalistic drawing taken from one of the photographs of November lilies on the opposite page

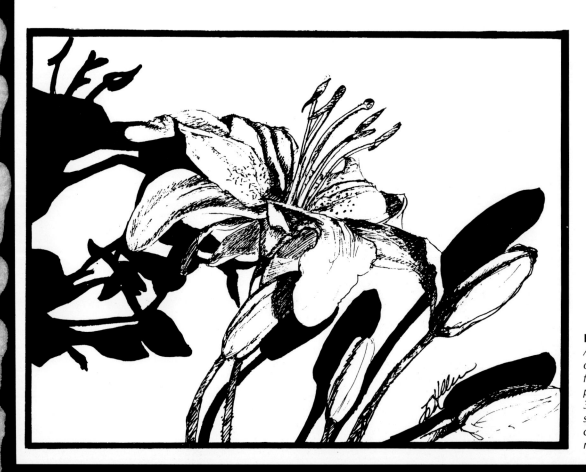

Fig. 15
A naturalistic drawing of pink lilies adapted from one of the photographs on page 34, showing the shadows black to create interesting negative shapes

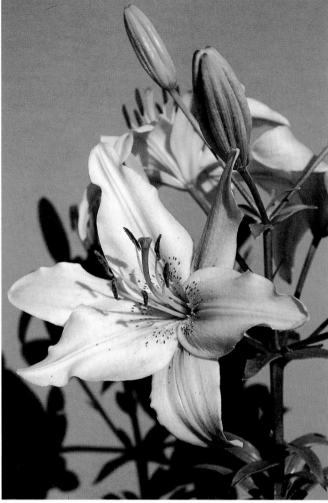

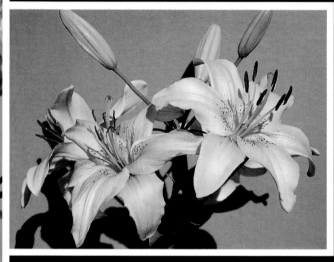

PINK LILIES

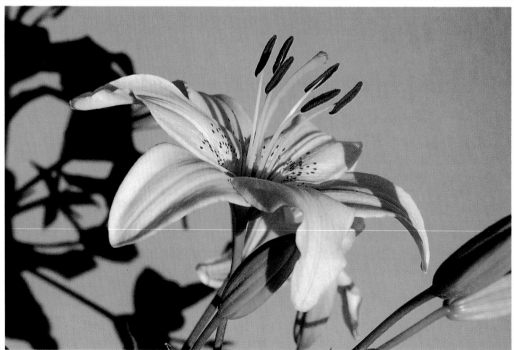

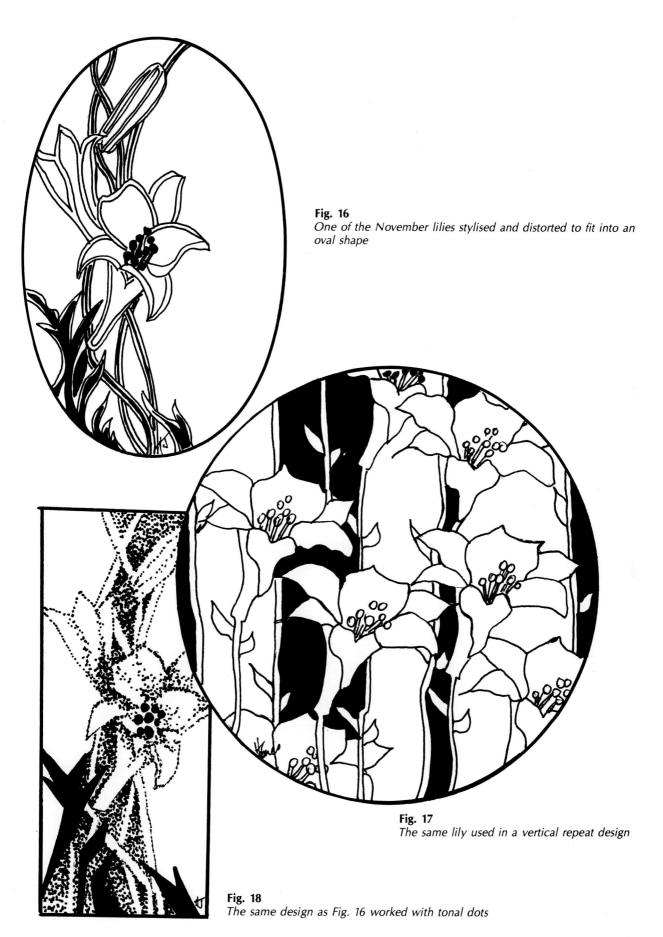

Fig. 16
One of the November lilies stylised and distorted to fit into an oval shape

Fig. 17
The same lily used in a vertical repeat design

Fig. 18
The same design as Fig. 16 worked with tonal dots

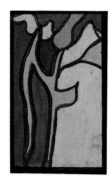
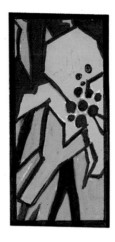
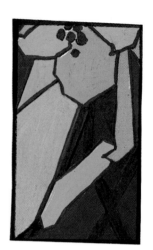
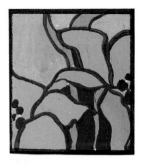
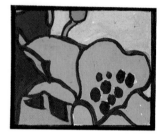
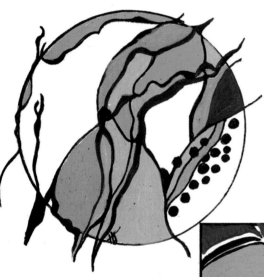

Fig. 19
Small croppings, abstracted and painted in gouache

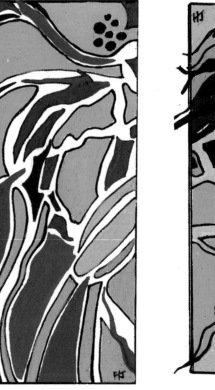
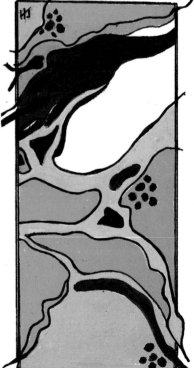

Fig. 20
The single pink lily from the naturalistic drawing on page 33 stylised with line extension into panels of background colour. Painted in gouache with gold acrylic

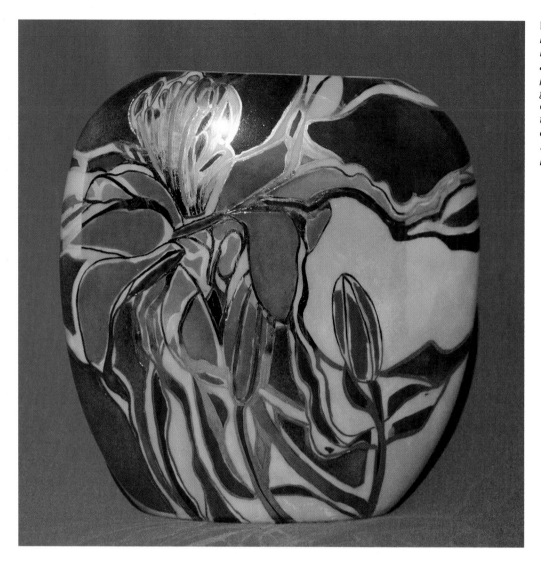

Fig. 5.1
*Helen Jones: 'Lilies'—
Painted in deep blue, ruby
and geranium onglaze
paint, copper metallic and
gold. The line extensions
continue onto the back of
the 16 cm pillow vase. The
design is adapted from
Fig. 20. Instructions
page 82*

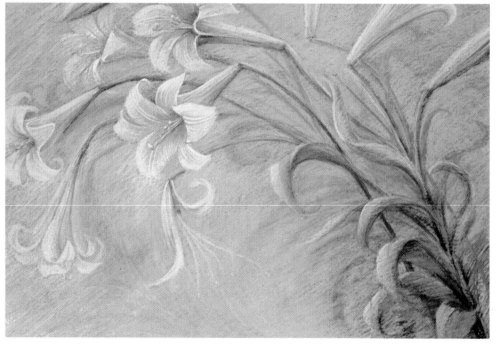

Fig. 5.2
*Heather Tailor: 'November Lilies'
(80 cm X 50 cm pastel)*

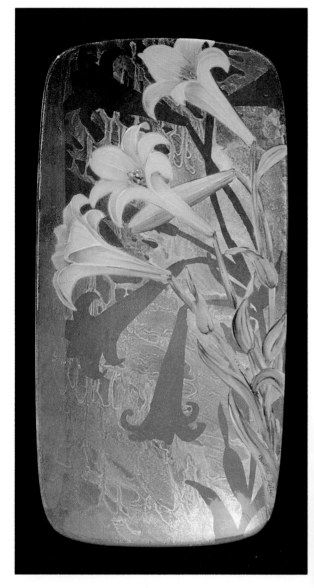

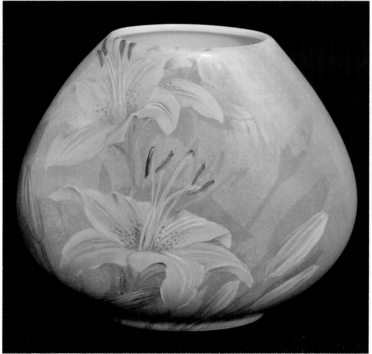

Fig. 5.3
Heather Tailor: 'November Lilies' (23 cm porcelain tray)—The lilies are painted in raised white texture with a lustred background dribbled with metallic. The design is adapted from one of the photographs on page 32. Instructions page 82

Fig. 5.4
Heather Tailor: 'Apricot Lilies' (16 cm vase)—The design is adapted from Fig. 15 and painted naturalistically with an apricot lustred background. Instructions page 83

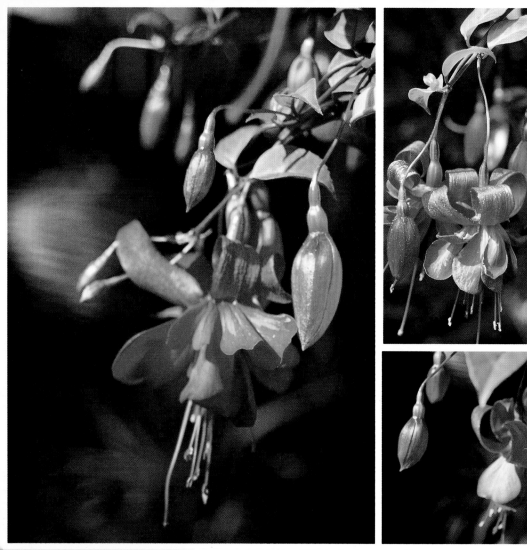

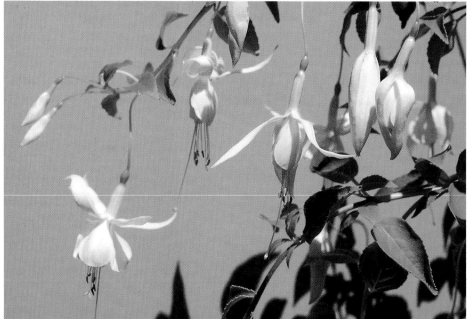

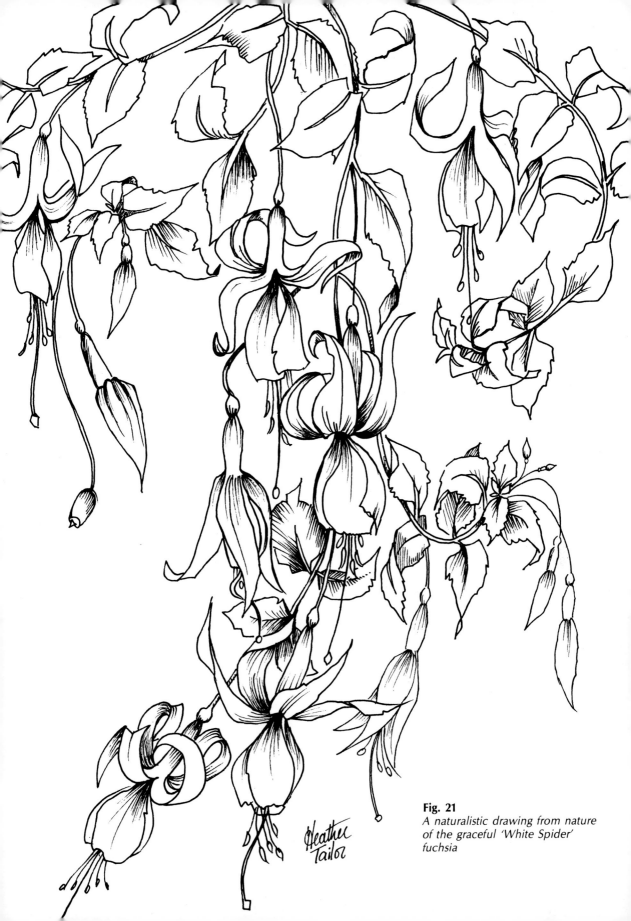

Fig. 21
*A naturalistic drawing from nature
of the graceful 'White Spider'
fuchsia*

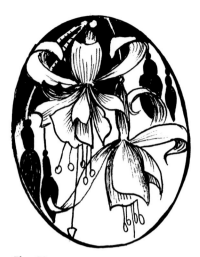

Fig. 23
Two selected flowers distorted to fit into an oval shape suitable for a jewellery pin

Fig. 24
The above design (Fig. 22) adapted for a ball-shaped vase

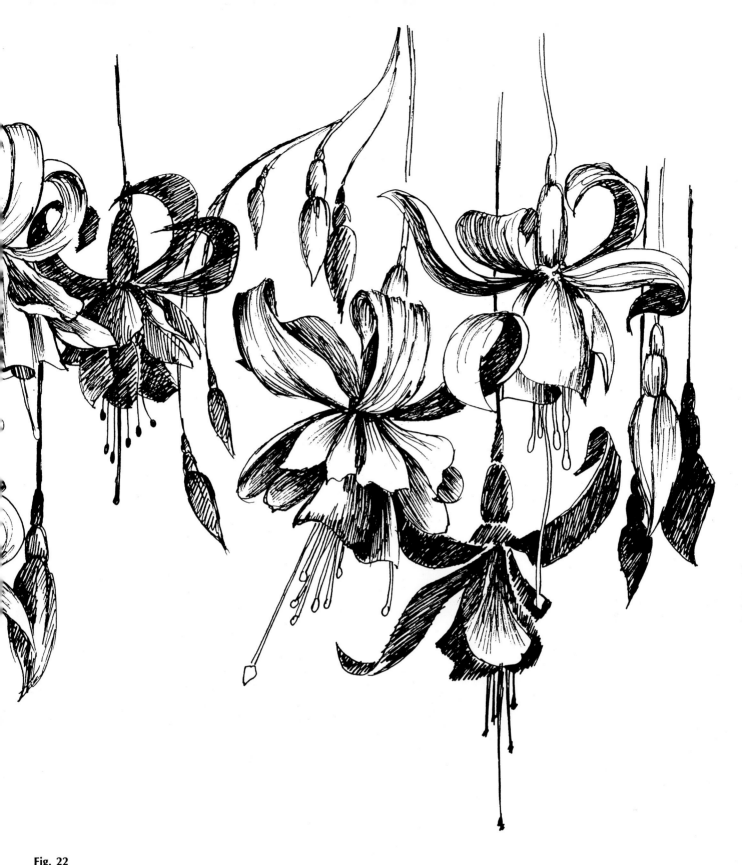

Fig. 22
A naturalistic line drawing of the double fuchsia 'Dark Eyes' adapted from the photographs

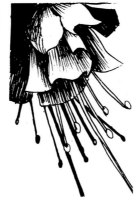

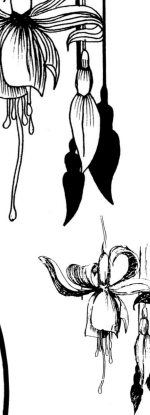

Fig. 25
*A small cropping from Fig. 22
of the lower half of a fuchsia,
reversed to make a pair*

Fig. 28
*A fuchsia and buds cropped
from Fig. 22 and arranged
against a panel of swirling
lines*

Fig. 26
*The same motif as Fig. 25 in a
symmetrical repetitive design*

Fig. 27 *(below)*
*Another single flower cropped from
Fig. 22, repeated for a horizontal
border design*

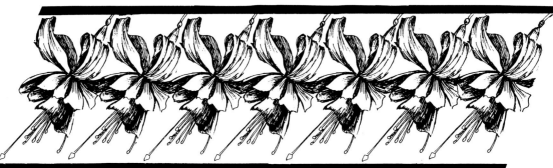

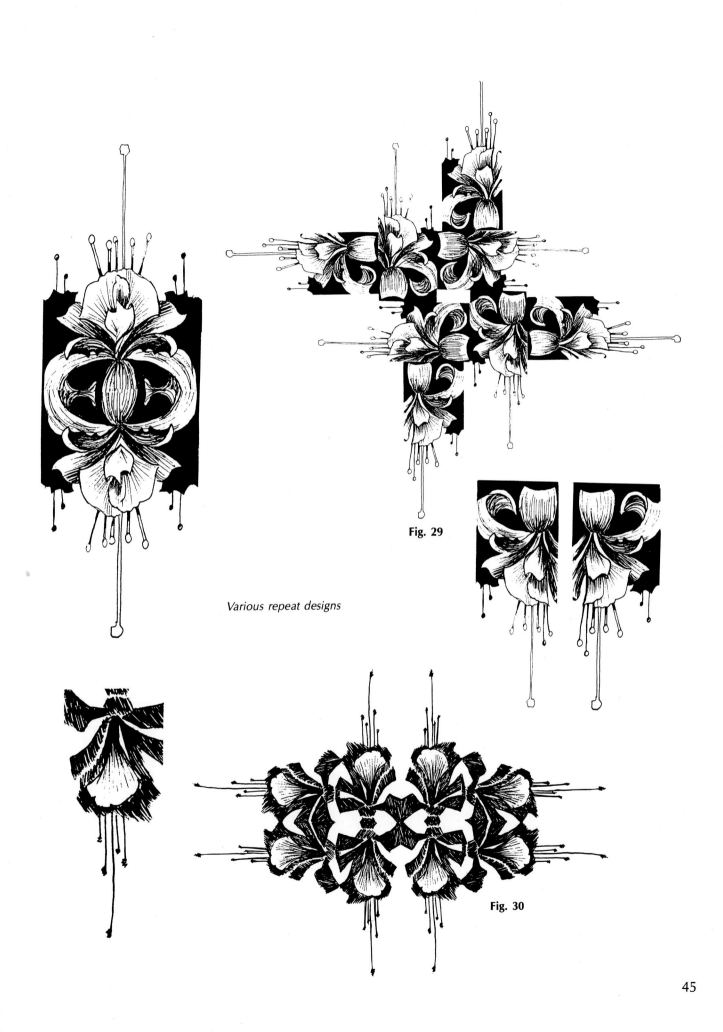

Various repeat designs

Fig. 29

Fig. 30

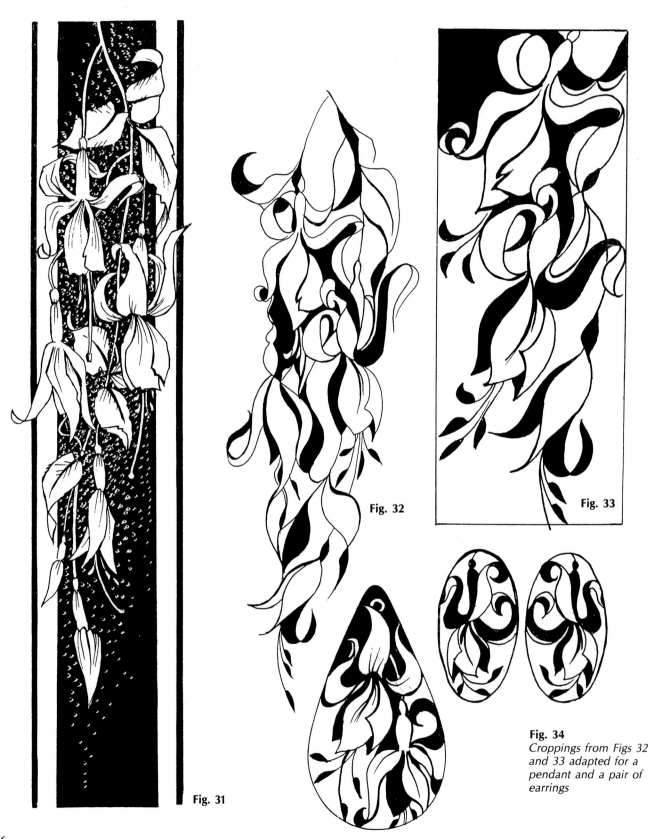

Fig. 31
A selected area from Fig. 21, the drawing of the 'White Spider' fuchsia, distorted into a long vertical panel with the design breaking into the white side panels. White dot work softens the contrast and creates a shimmering effect

Figs. 32 and 33
The panel design (Fig. 31) further stylised by extending the lines and creating alternate shapes of black and white.

Fig. 31

Fig. 32

Fig. 33

Fig. 34
Croppings from Figs 32 and 33 adapted for a pendant and a pair of earrings

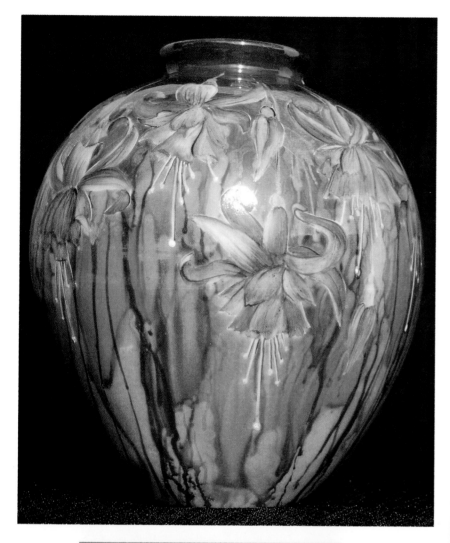

Fig. 6.1
Heather Tailor: 'Ruby Fuchsias' (17 cm ball vase)—The colours and design were inspired by the photographs of the double fuchsia 'Dark Eyes' and the drawings Figs 22 and 24. The background is several layers of dribbled lustre with the flowers painted naturalistically. Instructions page 83

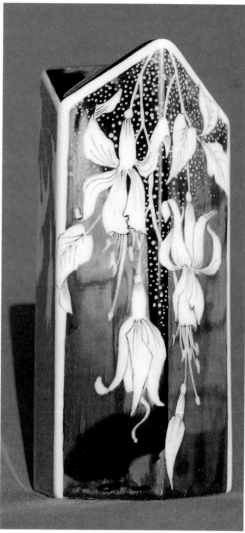

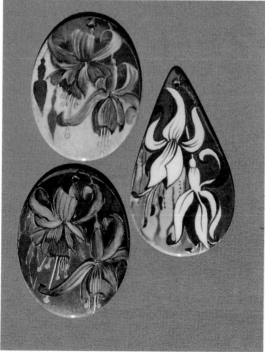

Fig. 6.2
Heather Tailor: 'Spider Fuchsias' (17 cm six-sided vase)—Lustre resist, black lustre and pearl have been used to paint this panelled vase. The design is slightly different on each panel and was adapted from Fig. 31. Instructions page 83

Fig. 6.3
Heather Tailor: 'Three jewellery pieces' (6 cm to 8 cm)—The three pieces are painted in the same technique with similar colours. The designs are Figs 23 and 34. Instructions page 83

CHAPTER 7 AGAPANTHUS

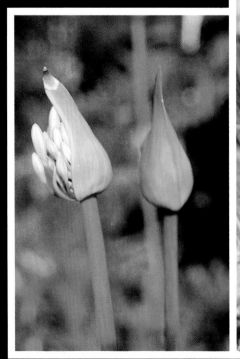

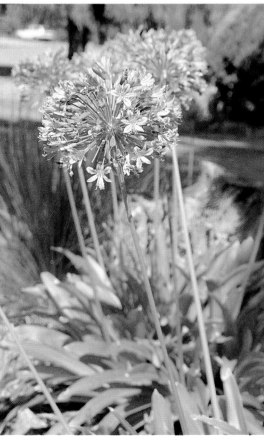

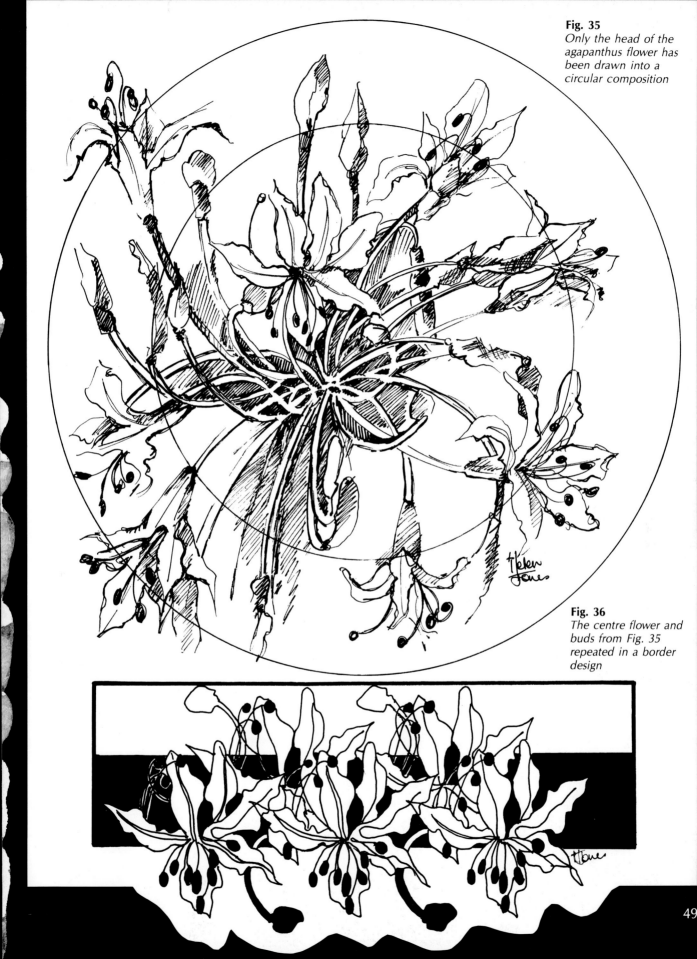

Fig. 35
Only the head of the agapanthus flower has been drawn into a circular composition

Fig. 36
The centre flower and buds from Fig. 35 repeated in a border design

49

Fig. 37
The first circular design (Fig. 35) has been simplified and stylised by removing the shadow, exaggerating the flowers and stamens and creating interesting negative space in between the centre stem work. The inner ring has been removed but the outer ring remains to emphasise the circular effect on the square panel

Fig. 38 *(below)*
Part of the same design reversed into silhouettes on a white ground

Fig. 37

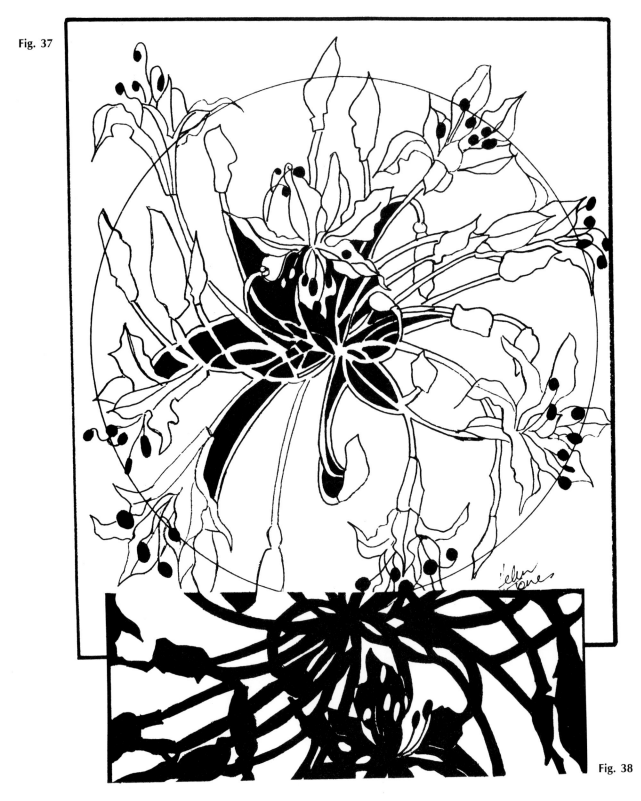

Fig. 38

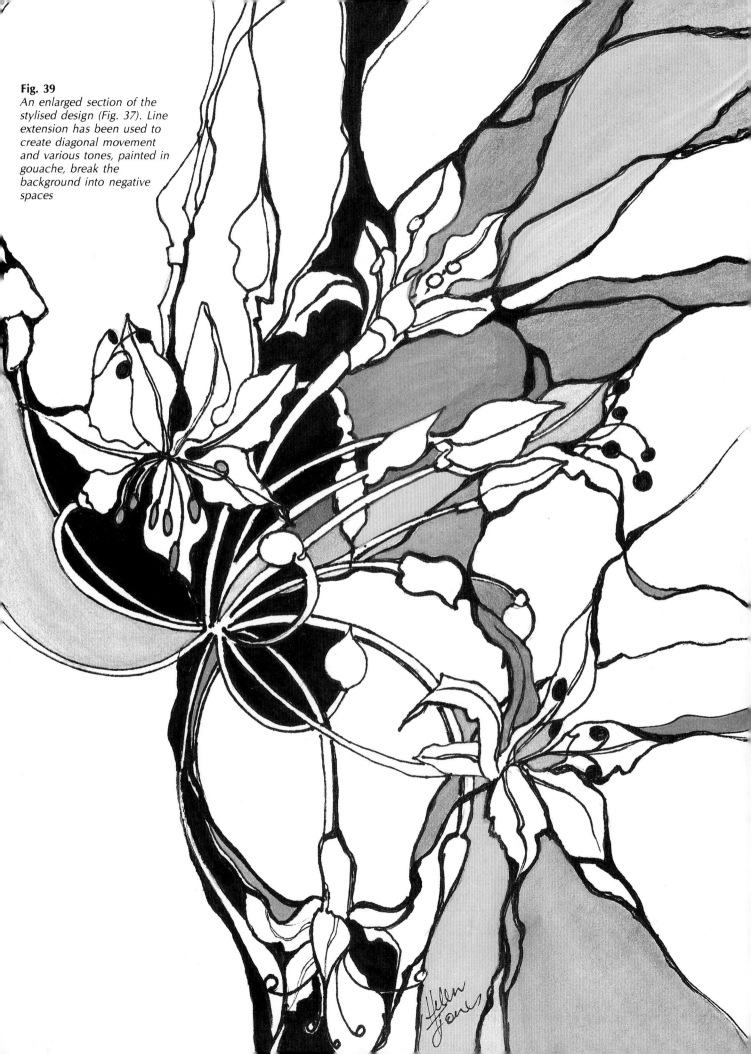

Fig. 39
An enlarged section of the stylised design (Fig. 37). Line extension has been used to create diagonal movement and various tones, painted in gouache, break the background into negative spaces

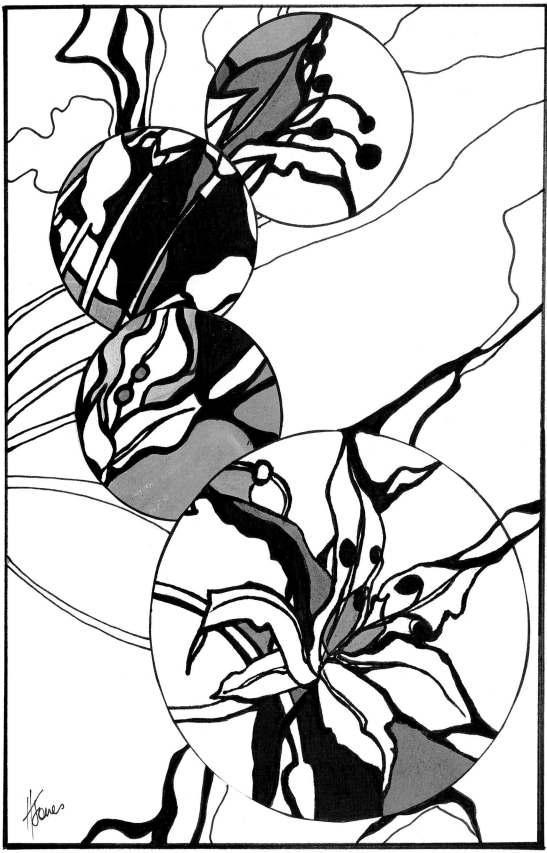

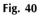

Fig. 40
Enlarged circular croppings from Fig. 39 are superimposed onto an enlarged part of the line extension

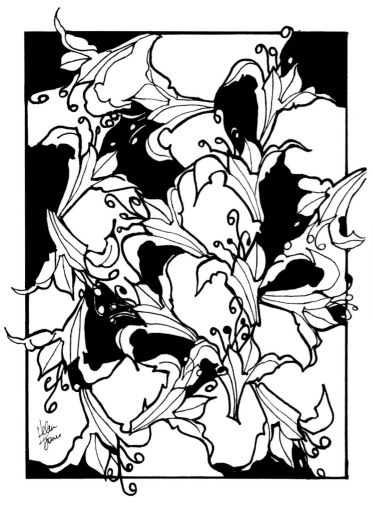

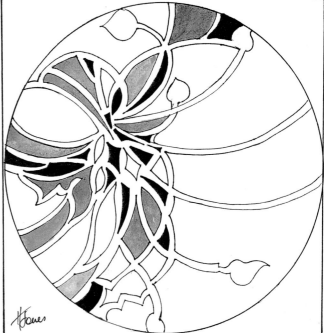

Fig. 42
The inner section of the stems and buds from Fig. 37 with sections of negative space blocked in

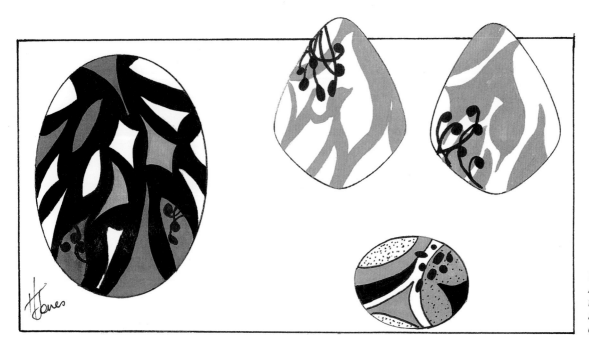

Fig. 43
Abstract croppings feature the stamens as an additional decorative element

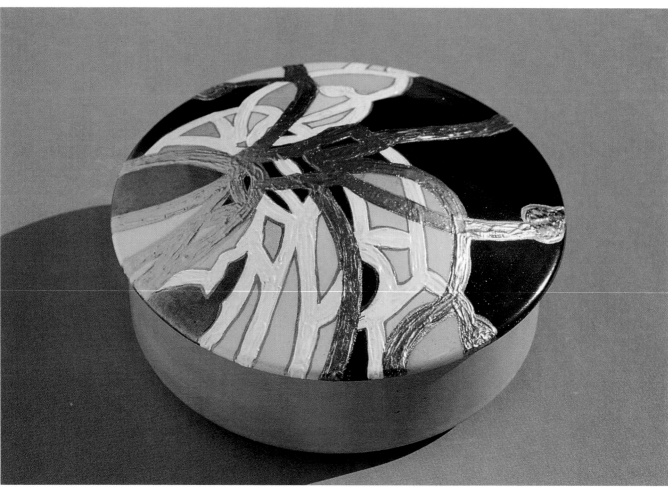

Fig. 7.1
Helen Jones: 'Agapanthus Stems' (17 cm box)—An adaptation of Fig. 42 painted onto the lid of a large porcelain jewel box in black, white texture, copper and mauve metallic. Instructions page 83

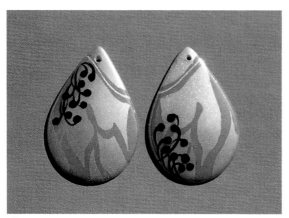

Fig. 7.2
Heather Tailor: 'Earrings' (5 cm)—An adaptation of Fig. 43 painted in light blue lustre, metalic and black enamel. Instructions page 83

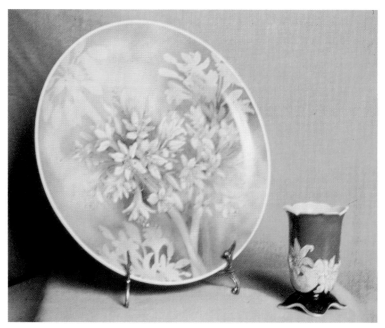

Fig. 7.3
Helen Jones: 'Agapanthus' (32 cm pavlova plate and small vase)

54

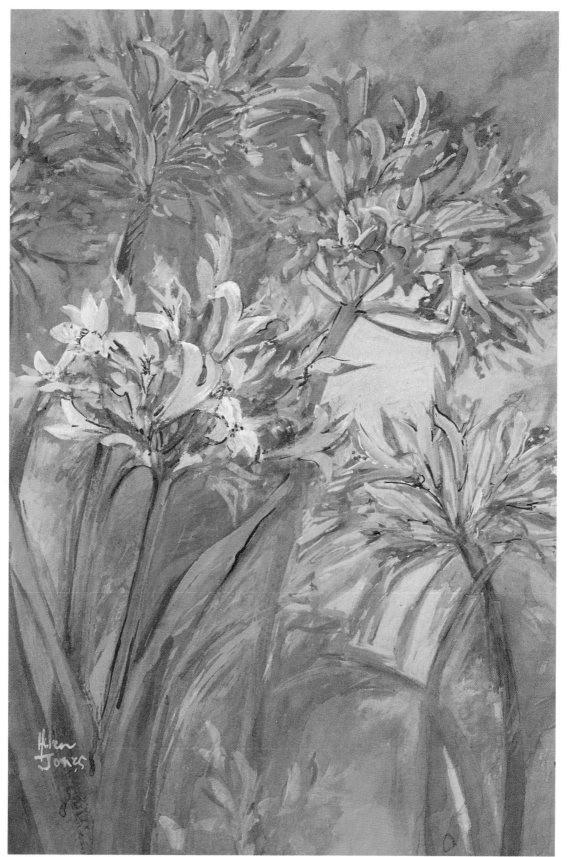

Fig. 7.4
Helen Jones: 'Agapanthus' (56 cm × 80 cm acrylic)

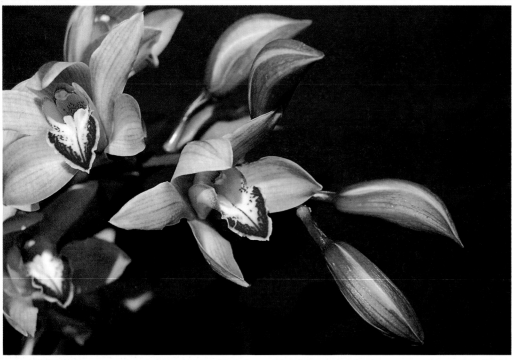

CYMBIDIUM ORCHIDS

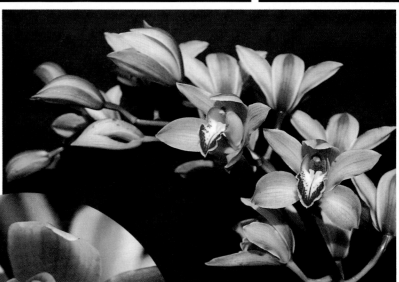

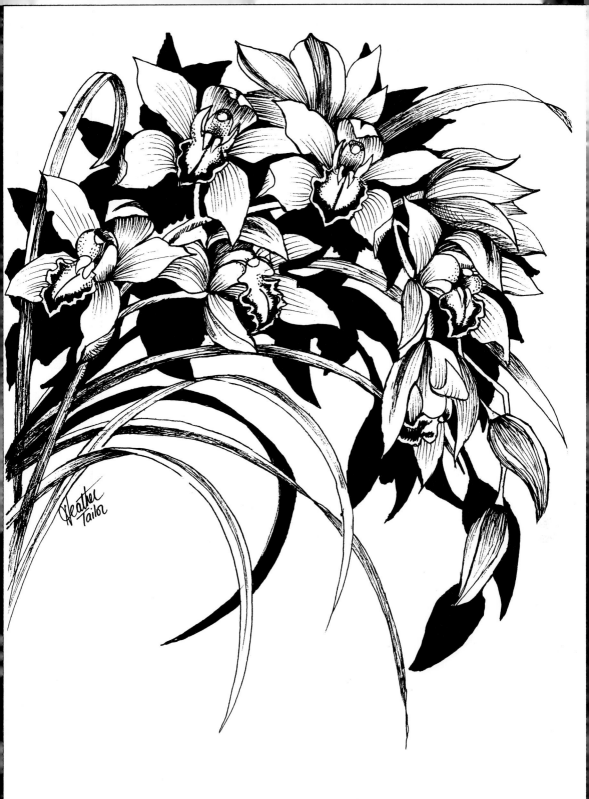

Fig. 44
A blue board was used as a backdrop for the orchid photographs to capture the shadow shapes. The orchids have been arranged and drawn naturalistically from the photographs and the shadows blacked in behind the flowers to create interesting negative shapes

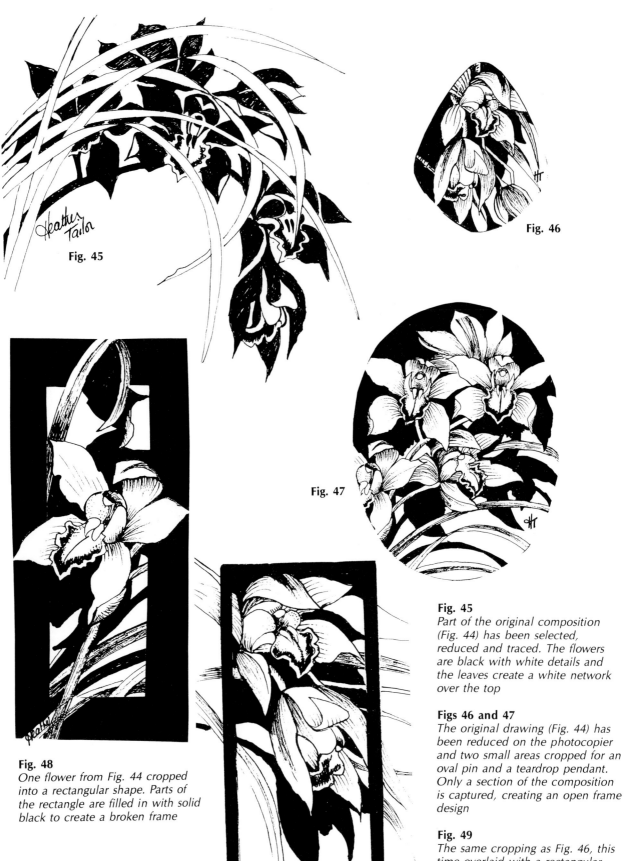

Fig. 45

Fig. 46

Fig. 47

Fig. 48
One flower from Fig. 44 cropped
into a rectangular shape. Parts of
the rectangle are filled in with solid
black to create a broken frame

Fig. 45
Part of the original composition
(Fig. 44) has been selected,
reduced and traced. The flowers
are black with white details and
the leaves create a white network
over the top

Figs 46 and 47
The original drawing (Fig. 44) has
been reduced on the photocopier
and two small areas cropped for an
oval pin and a teardrop pendant.
Only a section of the composition
is captured, creating an open frame
design

Fig. 49
The same cropping as Fig. 46, this
time overlaid with a rectangular
frame to create an open frame
design

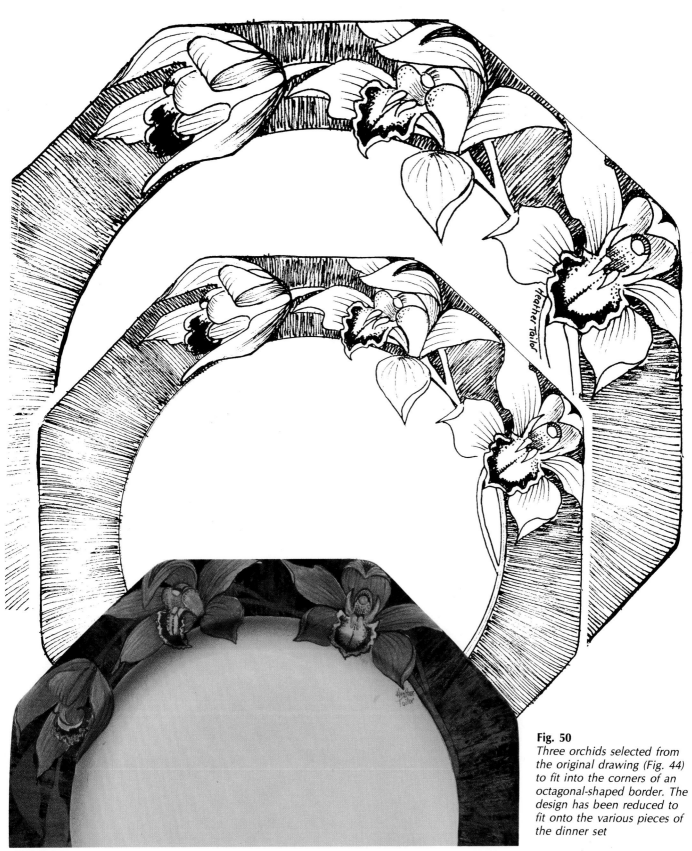

Fig. 50
Three orchids selected from the original drawing (Fig. 44) to fit into the corners of an octagonal-shaped border. The design has been reduced to fit onto the various pieces of the dinner set

Fig. 8.1
Heather Tailor: 'Cymbidium Orchids' (25 cm octagonal dinner plate)—The first piece of a proposed 20 piece dinner set using a design of three orchids on the rim. Painted in two firings, the red background is printed with black paint and plastic wrap. Instructions pages 83-84

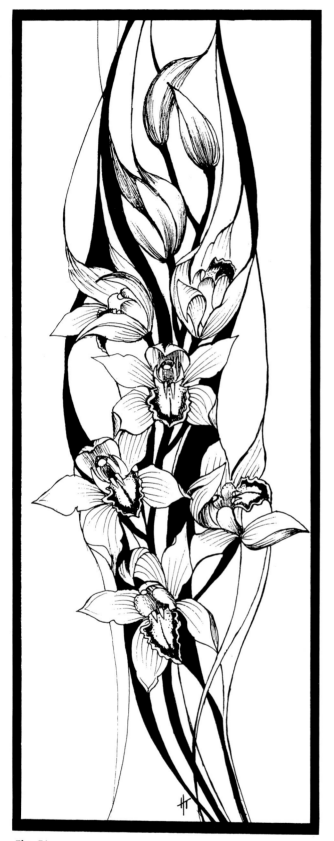

Fig. 51
The orchids have been redrawn and stylised into a vertical panel with line extensions

Fig. 52
From Fig. 51 the design has been reduced and the line extensions modified for the oval shape

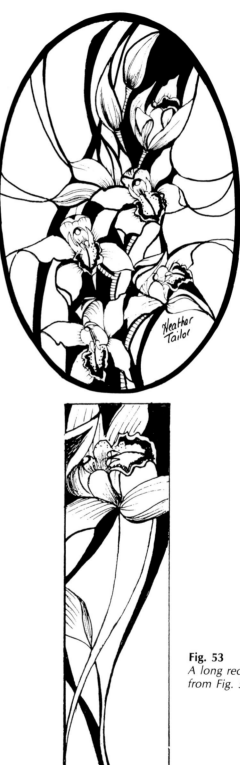

Fig. 53
A long rectangular cropping from Fig. 51

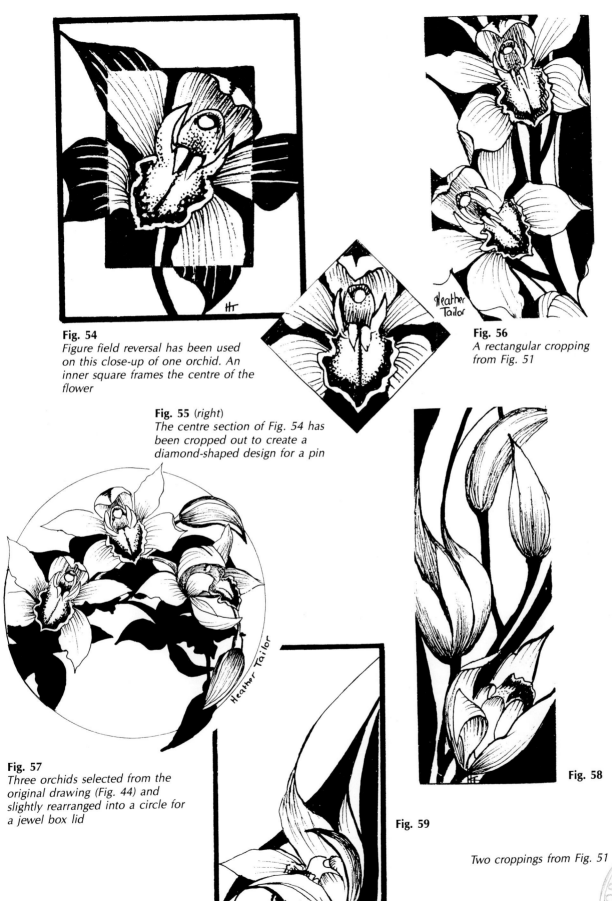

Fig. 54
Figure field reversal has been used on this close-up of one orchid. An inner square frames the centre of the flower

Fig. 55 (right)
The centre section of Fig. 54 has been cropped out to create a diamond-shaped design for a pin

Fig. 56
A rectangular cropping from Fig. 51

Fig. 57
Three orchids selected from the original drawing (Fig. 44) and slightly rearranged into a circle for a jewel box lid

Fig. 59

Fig. 58

Two croppings from Fig. 51

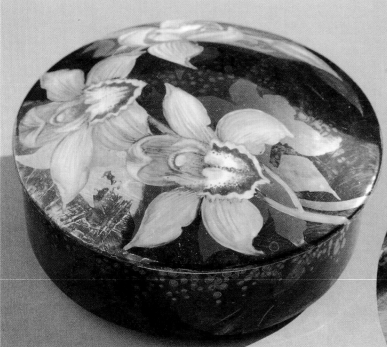

Fig. 8.2
*Heather Tailor: 'Gold Orchids' (17 cm box)—
The background colour of this large jewel box
is copper and blue lustre which has been
spotted with solvent to create the halos. The
orchids (Fig. 57) are painted naturalistically and
shaded with cobalt blue reflections. Instructions
page 84*

Fig. 8.3
*A close-up of the lid showing the intense
blue reflections of the lustred surface from
certain angles*

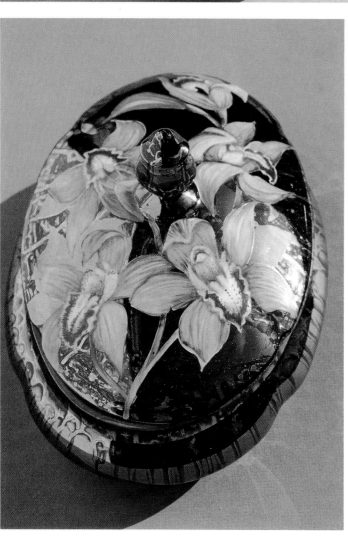

Fig. 8.4
*Heather Tailor: 'Orchid Candy Box' (18 cm)—The design
features a spike of orchids distorted to fit on the lid of this
large box. Weeping opal has been applied over copper lustre
to create an unusual iridescent effect. Instructions page 84*

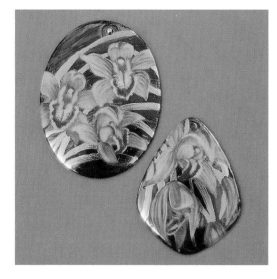

Fig. 8.5
Heather Tailor: 'Orchid Pin and Pendant' (6 cm)—Two small croppings (Figs 46 and 47) from the original drawing, reduced to fit onto these two pieces of porcelain jewellery. The flowers are painted naturalistically with an iridescent copper/blue background and gold leaves. Instructions page 84

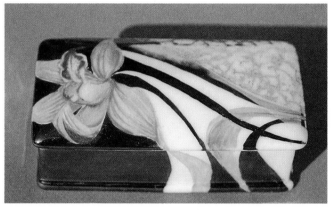

Fig. 8.6
Heather Tailor: 'Miniature Orchid Box' (8 cm)—The design (Fig. 53) is painted in marbelised copper, platinum and yellow, ochre and red onglaze paint. Instructions page 84

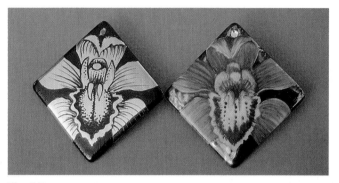

Fig. 8.7
Heather Tailor: 'Orchid Pin and Pendant' (5 cm)—A close-up of one of the orchids (Fig. 55) is used for these two diamond-shaped pieces. One pin is painted in heliotrope and ruby and the other in black over gold. Instructions page 84

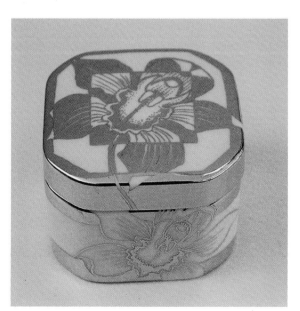

Fig. 8.8
Heather Tailor: 'Gold Orchid Box' (7 cm)—The centre of the orchid (Fig. 54) is painted in gold pen work into an inner frame; the petals reverse to solid gold in the outer frame. Instructions page 85

CHAPTER **9**

IRIS

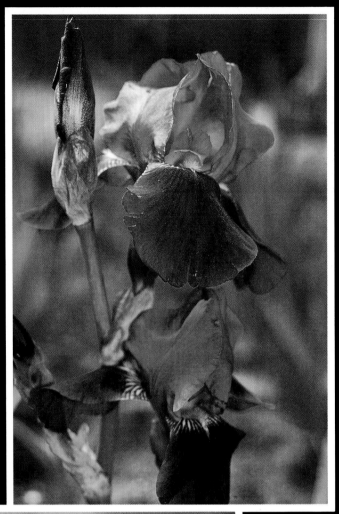

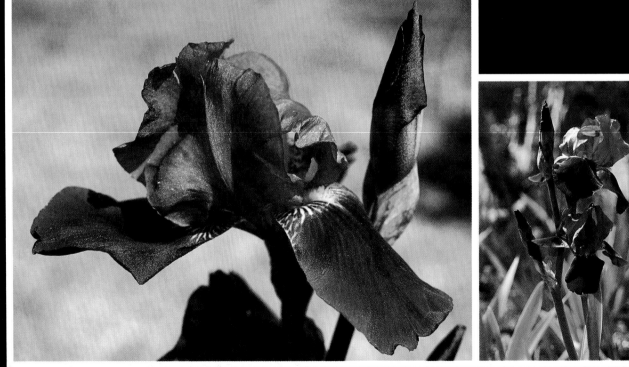

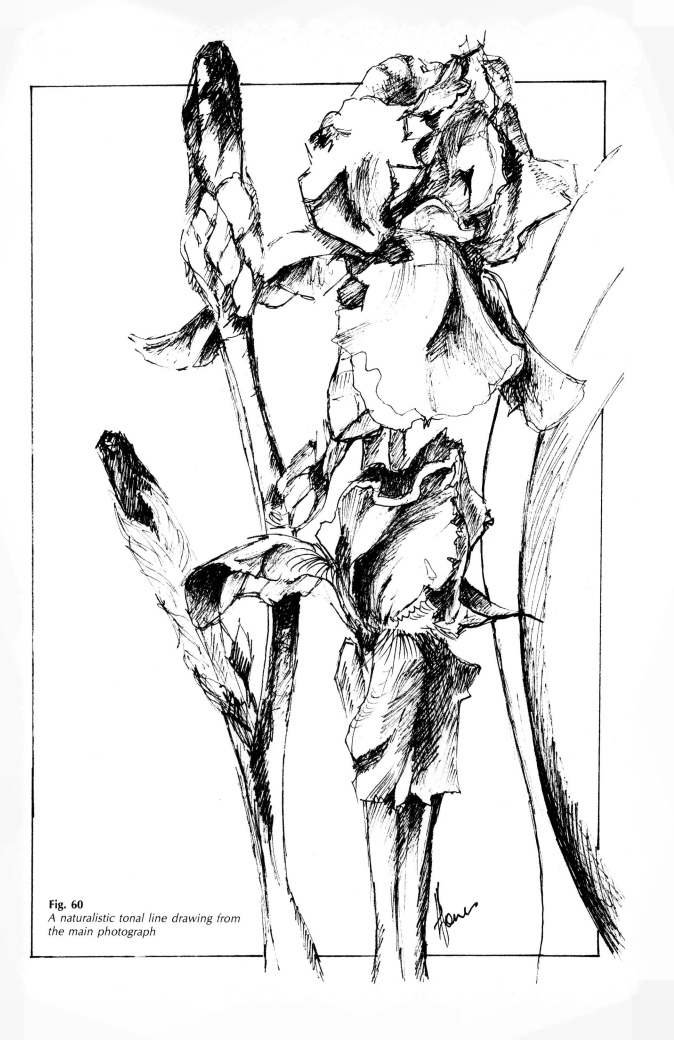

Fig. 60
A naturalistic tonal line drawing from the main photograph

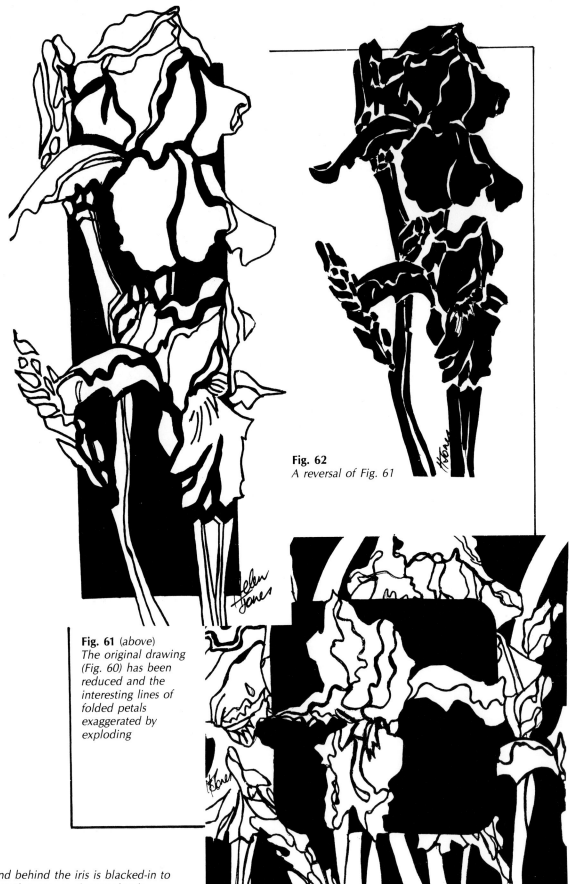

Fig. 62
A reversal of Fig. 61

Fig. 61 (above)
*The original drawing
(Fig. 60) has been
reduced and the
interesting lines of
folded petals
exaggerated by
exploding*

Fig. 63
*The background behind the iris is blacked-in to
create solid negative spaces. A cropping is
superimposed so that parts of the design link up*

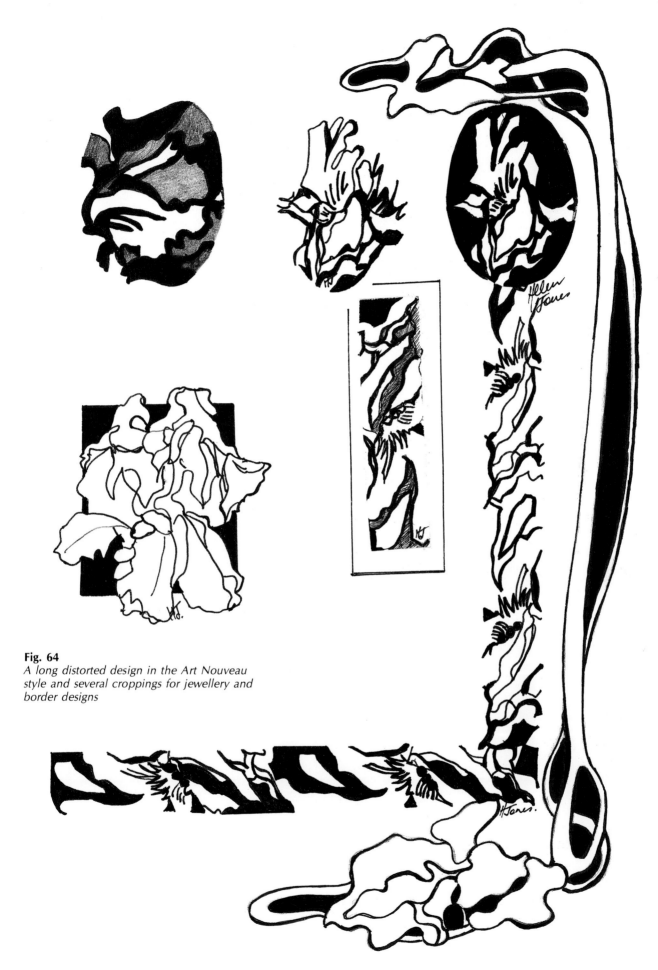

Fig. 64
A long distorted design in the Art Nouveau style and several croppings for jewellery and border designs

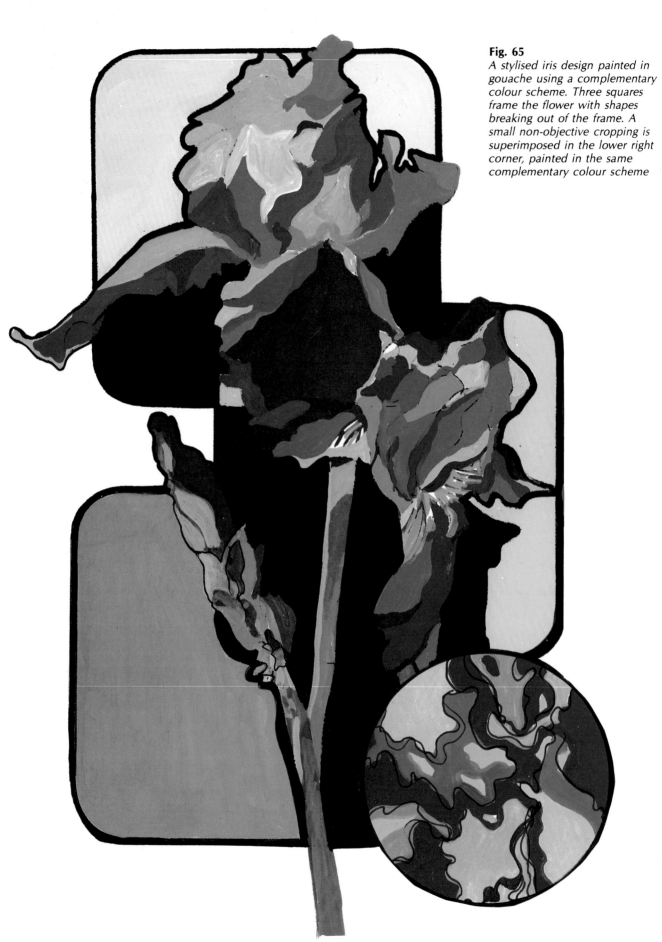

Fig. 65
A stylised iris design painted in gouache using a complementary colour scheme. Three squares frame the flower with shapes breaking out of the frame. A small non-objective cropping is superimposed in the lower right corner, painted in the same complementary colour scheme

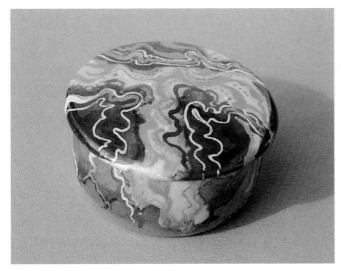

Fig. 9.1
Heather Tailor: 'Jewel Box' (8 cm)—Inspired by Fig. 65 and the complementary colour combination of ruby, violet, cinnamon lustre and copper metallic. Instructions page 85

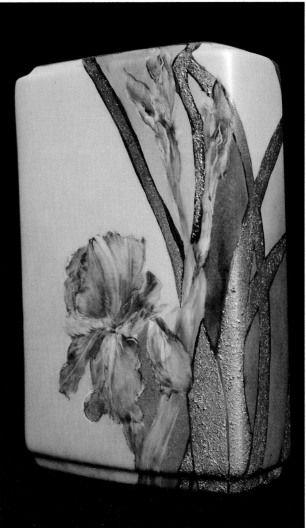

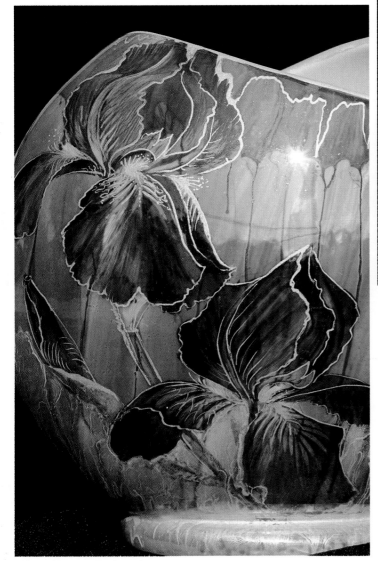

Fig. 9.2
Helen Jones: 'Iris' (20 cm rectangular vase)—The complementary colours of violet, blue, ochre and sepia have been used on this iris design based on the original drawing (Fig. 60). The background is grounded in two tones of metallic and the stylised leaves, which extend around the back, are gold over texture. Instructions page 85

Fig. 9.3
Heather Tailor: 'Iris' (20 cm vase)—The flowers, based on Figs. 60 and 65, are painted in lustres. A dribble technique has been used to create a random pattern of complementary colours in the background, and the design is detailed with gold metallic. Instructions page 85

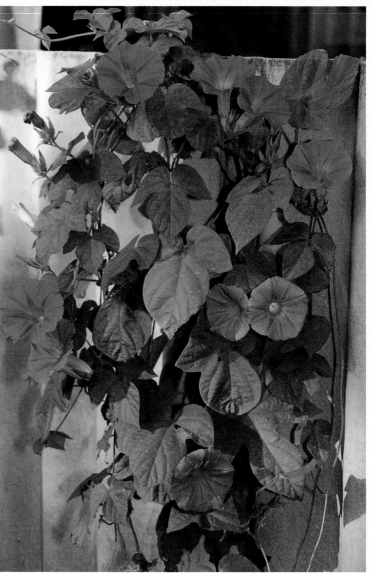

CHAPTER **10**

MORNING GLORY

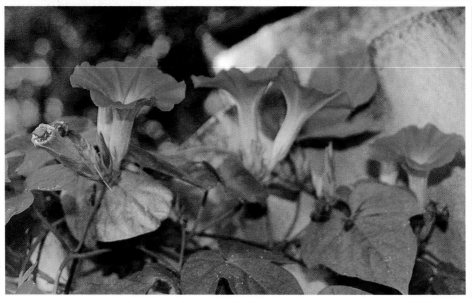

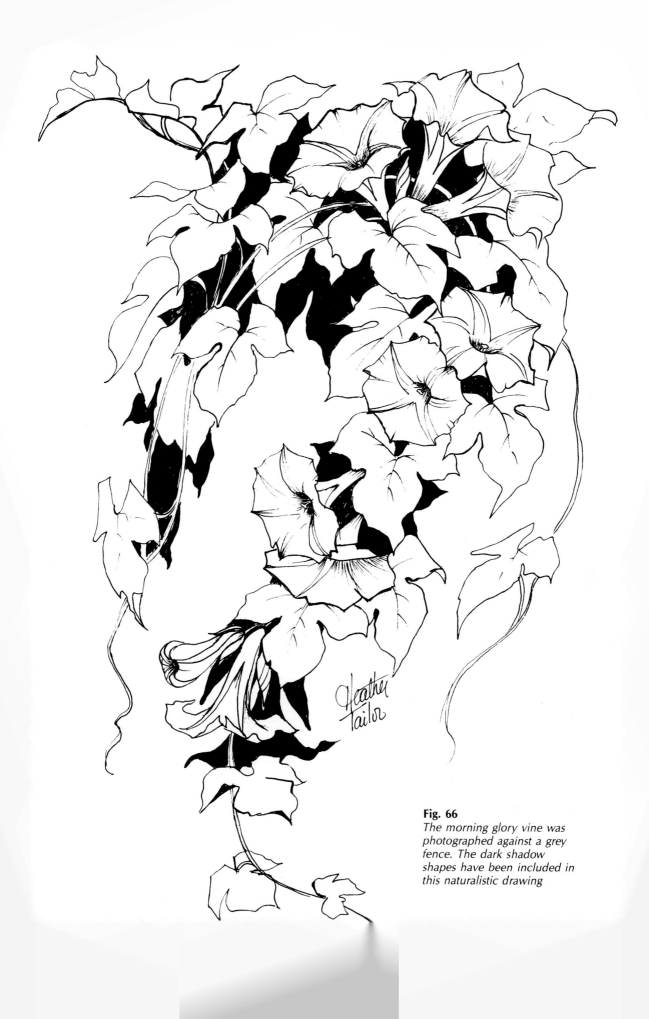

Fig. 66
*The morning glory vine was
photographed against a grey
fence. The dark shadow
shapes have been included in
this naturalistic drawing*

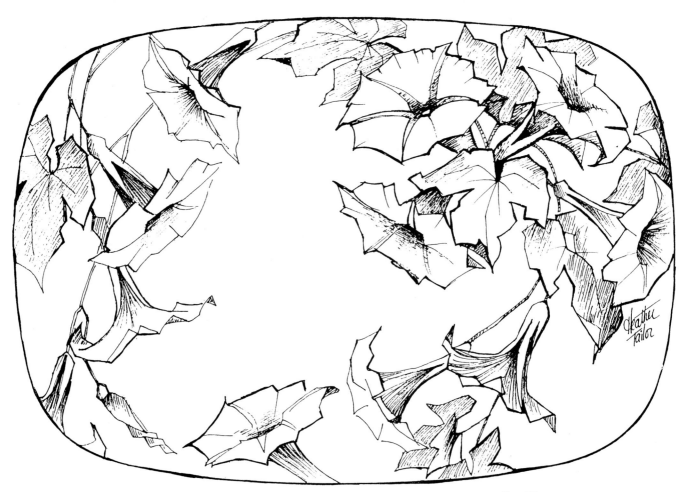

Fig. 67
Flower shapes from the original drawing (Fig. 66) have been rearranged into an open frame composition and stylised to exaggerate the crisp angles of the flowers and leaves

Fig. 68
The section on the right side of Fig. 67 has been reversed and modified for the lid and base of a box

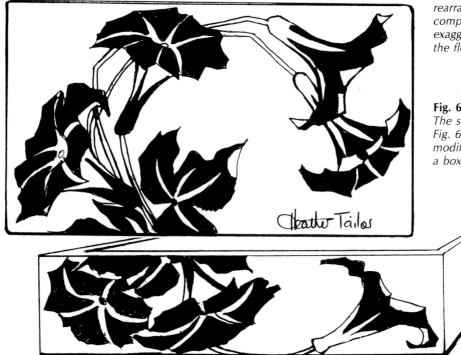

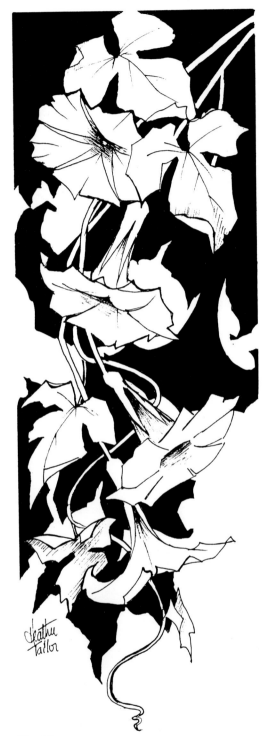

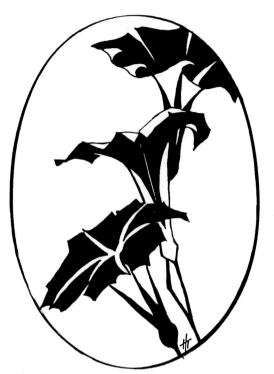

Fig. 70
Three side view flowers selected from Figs 67 and 68 are arranged diagonally across an oval shape, breaking the background into three areas of negative space

Fig. 69
Selected stylised flowers traced into a vertical panel. Black flower and leaf shapes break up the background

Fig. 71
The right half of Fig. 67 has been used with a white panel superimposed in the centre to create a wide frame. The flowers reverse values around the frame

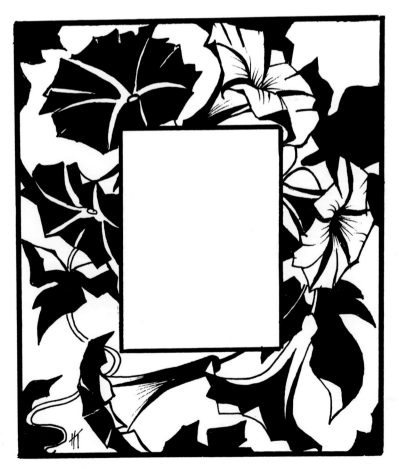

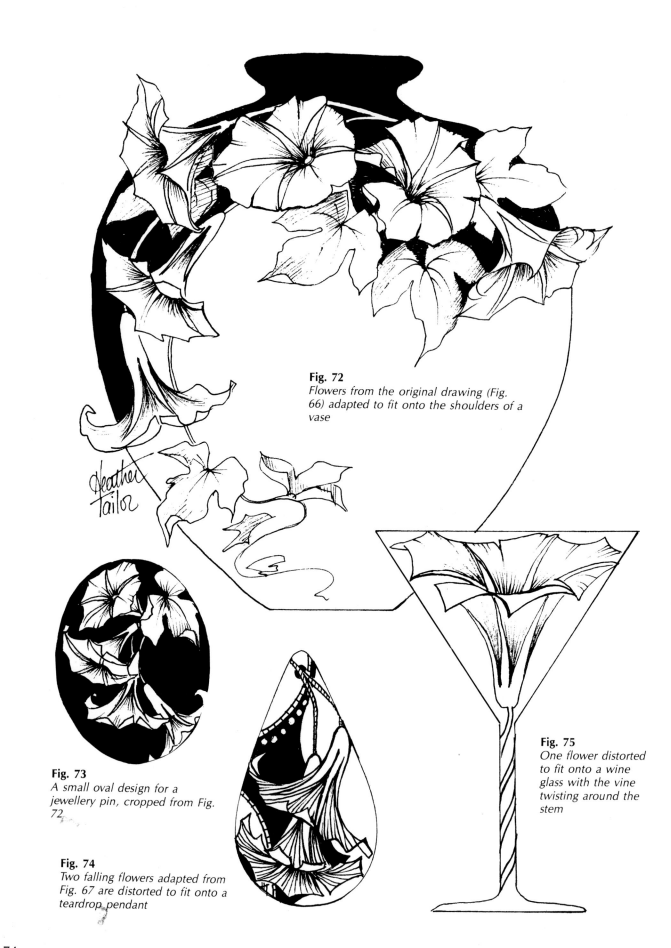

Fig. 72
Flowers from the original drawing (Fig. 66) adapted to fit onto the shoulders of a vase

Fig. 73
A small oval design for a jewellery pin, cropped from Fig. 72.

Fig. 74
Two falling flowers adapted from Fig. 67 are distorted to fit onto a teardrop pendant

Fig. 75
One flower distorted to fit onto a wine glass with the vine twisting around the stem

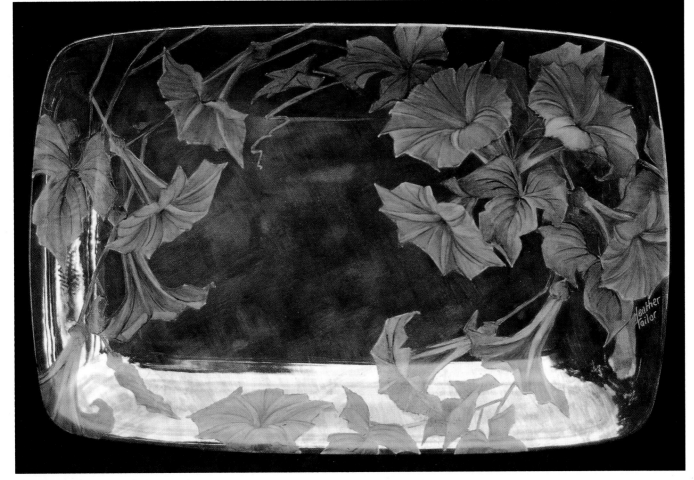

Fig. 10.1
Heather Tailor: 'Morning Glory' (30 cm platter)—The flowers are painted naturalistically with an iridescent grey/violet lustred background, created by cross-hatched brush strokes of different lustres. The design is adapted from Fig. 67. Instructions page 85

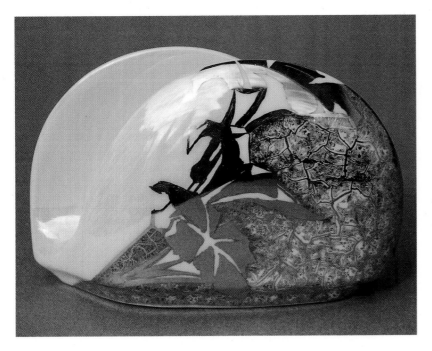

Fig. 10.2
Heather Tailor: 'Gold Morning Glory' (serviette holder)—The design of three flowers (Fig. 70) is painted in gold diagonally across the piece and features a marbelised gold background on one side. Instructions page 85

CORAL TREE

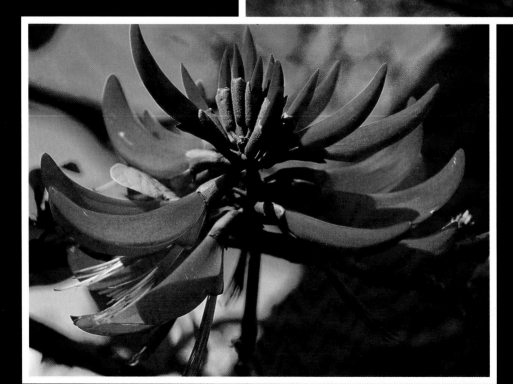

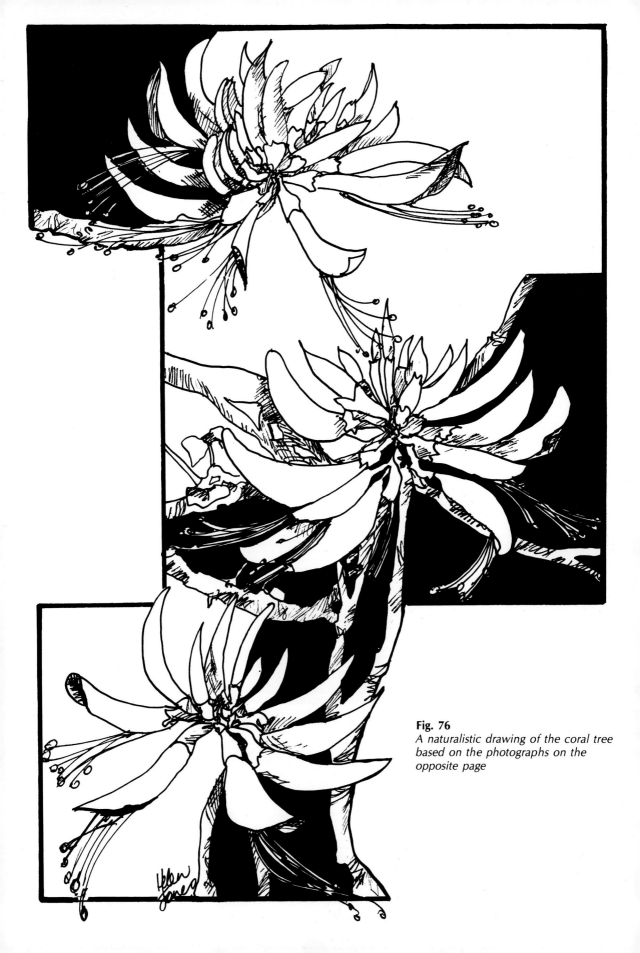

Fig. 76
A naturalistic drawing of the coral tree based on the photographs on the opposite page

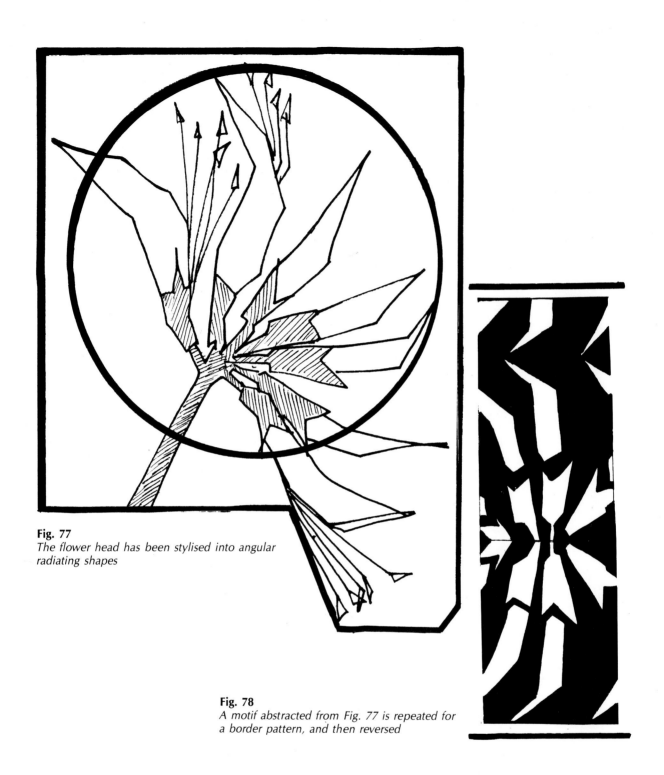

Fig. 77
The flower head has been stylised into angular radiating shapes

Fig. 78
A motif abstracted from Fig. 77 is repeated for a border pattern, and then reversed

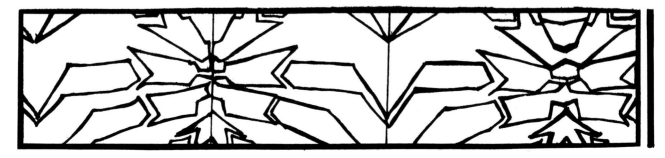

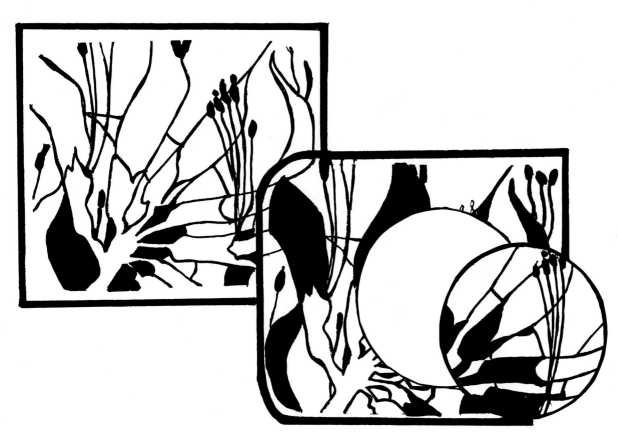

Fig. 79
A cropped section of the design with a central circle cut and lifted to one side

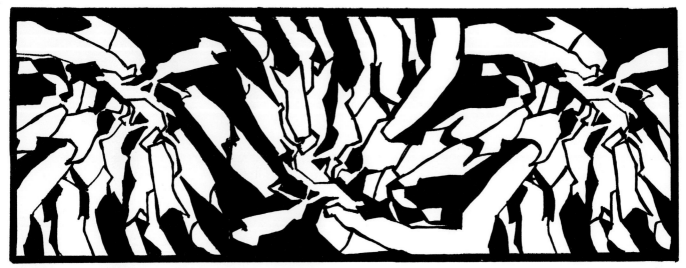

Fig. 80
A border panel from an abstracted section

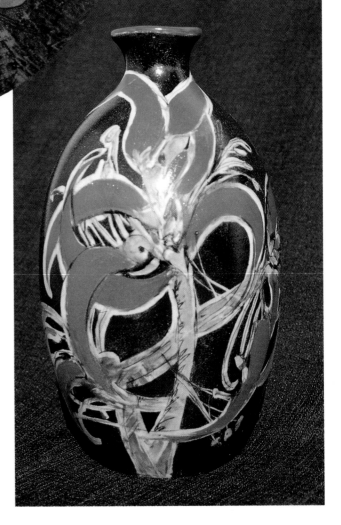

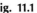

Fig. 11.1
Heather Tailor: 'Coral Tree' (25 cm platter)—The design is based on Fig. 76 and painted in Meissen red with black paint printed on top to produce an unusual texture. Instructions page 85

Fig. 11.2
Helen Jones: 'Coral Tree' (21 cm bottle vase)—The flower spikes of the coral tree are painted in cadmium red with strong sweeping brush strokes. Instructions page 85

CHAPTER 12

APPLYING THE DESIGNS TO PORCELAIN AND CERAMIC

We have kept instructions for applying the designs to porcelain and ceramic brief and to the point as there are three excellent books available which provide detailed instructions for the hand decorating techniques used on the pieces illustrated in this book.

For all techniques involving lustre, such as sponge and brushwork, firing, lustre colours, resist, marbelising effects, halo and dribbling techniques, refer to *Lustre for China Painters and Potters* by Heather Tailor, published by Kangaroo Press, Sydney, 1990.

For techniques involving textures, raised pastes, gold underlay, enamels, petit point and acid look effects, refer to *Textures and Techniques for Porcelain and Ceramics* by Sandra L. Brown, published by Kangaroo Press, Sydney, 1991.

For information regarding different surfaces to paint on, onglaze paint and how to mix it, mediums, transferring a design to the surface, stencilling techniques, firing and kilns, and technical instruction on pen work, sponge painting, brush strokes, grounding, metallics, enamel and gold, refer to *Easy Onglaze Techniques for China Painters and Potters* by Heather Tailor, published by Kangaroo Press, Sydney, 1992.

Note: Up to the time of writing, the product Lustre Resist #3 was readily available, but it has since become difficult to obtain. If you cannot locate a supply, use Pelikan Plaka (any colour) or gouache paint as a resist. Both products will resist lustre if applied heavily. They are water-based and available from art shops. After firing, re-apply the resist if necessary.

Fig. 3.1 Nasturtiums—*17 cm round porcelain box*

1. The design was adapted from Fig. 4, page 20.
2. Yellow lustre was applied with a sponge to the entire box and fired to 720°C.
3. The yellow nasturtium shapes were masked with resist. When it was dry, orange lustre was sponged over the lid and base of the box and fired to 720°C.°
4. The fired resist covering the yellow shapes was left intact. Large orange bands and orange nasturtium shapes were covered with fresh resist and violet lustre sponged over the remaining exposed areas, resulting in a deeper shade. The box was fired to 720°C.
5. After firing the resist was cleaned off, revealing a pattern of yellow and orange shapes. Texture coat mixed with glycerine was painted in wavy bands over the box to represent the superimposed stem work. Small dots were also added to the centres of the nasturtiums. The box was fired to 800°C.
6. Liquid bright gold was applied with a fine brush to the texture coat bands and detailing. The box was fired for the final time to 720°C.

Fig. 3.2 Nasturtiums—*6 cm X 4 cm porcelain pendant*

1. The design is adapted from the naturalistic drawing, Fig. 1, page 19.
2. Only the flowers, stems and buds were drawn onto the pendant and covered with resist.
• A coat of liquid bright gold was painted over the surface; when 'just' dry it was marbelised with marbelising solution.
• The piece was fired to 720°C.
3. The resist was cleaned off, revealing the design as a white silhouette on the marbelised gold. The flowers were then painted with onglaze colours and fired to 800°C.
4. Nasturtium leaves were drawn over the marbelised gold and penned in with black paint. The remaining background was painted black leaving only the leaves showing the gold marbelising effect. The flowers were reworked with colour and the pin fired for the last time to 800°C.

Fig. 4.1 Freesias—*bowl and platters*

These items were intended for functional use, and so no metallics, golds or lustres could be used. Each one shows how designs can be adapted to allow the maximum decorative effect with the minimum of firings.

Platter I—*soft glaze dinnerware*
1. The design incorporating line extension, Fig. 9 on page 26, was used to exploit both the simplicity of the composition and the techniques of penwork and sponge and grounding.
2. The design was transferred by carbon paper from a photocopy, penned in black paint, and fired at 760°C, as it is soft paste dinner ware.
3. The solid black areas were masked and grounded with black paint; the ruby area was sponged, and cling-wrap laid over the top and lifted to achieve the textural effect. The platter was fired at 760°C.
4. Grey paint was sponged over the textured area to soften the ruby colour, grey shadows were added to flowers and leaves and the pen lines tidied up where necessary. Fired again at 760°C.

Platter II—*soft glaze dinnerware*
1. The composition was adapted from Fig. 11 on page 27 after being enlarged on the photocopier and traced on with carbon paper.
2. The black areas were stencilled with clear sticky tape and grounded. The platter was fired at 760°C.
3. The grey and ruby areas were treated in the same manner, and the entire piece only required three firings.

Bowl—*porcelain*
1. A section of the design in Fig. 9 on page 26 was traced onto the bowl and the positive areas masked with lacquer. These areas were sponged in greys and olive greens and the bowl was fired at 800°C.
2. The black negative spaces were also masked and grounded, the positive areas touched up with sponge and again fired at 800°C.
3. Pale blue-grey was sponged in the right-hand negative space, ruby lines were penned in to define and add to the subject, and the piece fired at 800°C.

Fig. 4.3 Freesias—*naturalistic brushwork on porcelain vase*

1. The design from the original naturalistic drawings was adapted for the vase and drawn in freehand with a chinagraph pencil.
2. The colour and tonal values were then built up gradually with light washes, firing at 800°C between each layer.
3. After the third firing, texture coat was applied to the flowers to achieve a depth and whiteness, and the vase fired at 800°C.
4. A fourth firing was required for depth of colour at the base and for final detail.

Fig. 4.4 Freesias—*18 cm ✕12 cm terracotta vase with a clear glaze*

1. The flower shapes were adapted from the naturalistic drawings of freesias and drawn onto the surface freehand. In keeping with the casual earthy-looking vase, a free gestural style of painting was adopted.
2. With the vase on a turntable, the outlines of the flower shapes were drawn in with masking lacquer, using a fine brush. A band was masked halfway down the vase. Light and dark flesh coloured metallic paint was grounded onto the top half of the vase and a charcoal metallic onto the lower half. The mask was removed and the vase fired to 800°C. (The glaze on the mask was soft, therefore the metallic adhered at 30°C lower than porcelain.)
3. A dark ruby paint was mixed into a loose consistency with medium and turps and the design and band loosely outlined with a fine liner brush. The paintwork was fired to 780°C.
4. Lines of bright liquid gold were loosely applied around the flower shapes and band with a fine brush. The piece was fired to 700°C.

Fig. 4.5 Freesias—*7 cm ✕ 3 cm oblong porcelain pin*

1. The design was adapted from the photographs and painted directly onto the small tile with resist.
2. Two coats of black lustre were applied, each coat being fired separately to 720°C.
3. Mother-of-pearl was streaked over the lustre and refired to 720°C.
4. The resist was rubbed off and the design painted with texture coat. The tile was fired to 800°C.
5. The flowers, leaves and buds were painted with onglaze colours and fired to 800°C.

Fig. 5.1 Pink Lilies—*16 cm porcelain pillow vase*

1. The design is featured in Fig. 20 on page 37, painted in gouache colour. To transfer the design to the vase, the painting was photocopied and reduced, then traced onto tracing paper. The design was adapted to fit on one side of the vase, with the line extensions continuing onto the back.
2. The flowers, buds and stems, as well as the dark blue and ruby line areas, were all masked with waterbased grounding resist, and grounded. The grounding was repeated on the orange/pink areas. Copper metallic was used on the buds. This required three applications and firings at 800°C.
3. Grey lustre was applied with a sponge (using a brush in smaller areas). The lustre was fired to 720°C.
4. Liquid bright gold was applied with a fine brush and the vase fired for the last time to 720°C.

Fig. 5.3 November Lilies—*23 cm ✕ 11 cm porcelain tray*

1. The design was adapted from the photographs and drawn freehand onto the porcelain sandwich tray.
2. Resist was used to cover the flowers and foliage. Lustre thinner was added to light blue lustre to slow the drying, then sponged all over the surface. Blue lustre was sponged over the light blue at the top and gradually allowed to blend in half way down the design. The piece was fired at 720°C.
3. The resist was cleaned off to reveal white silhouettes of the lilies and foliage.
• Additional shadow shapes of lilies and leaves were drawn in the background and the entire design covered with masking lacquer.
• White metallic mixed with grounding oil and clove oil was applied at the edge of the design and induced to dribble across the surface by adding brushfuls of turpentine.
• When the metallic dribbles had settled, the masking lacquer was peeled off and the piece fired to 830°C.
4. Texture coat was used to 'model' the lilies and leaves and fired to 800°C.

5. The design was painted with onglaze colours and fired for the fourth and final time to 800°C.

Fig. 5.4 Apricot Lilies—*16 cm porcelain vase*

1. The design, drawn onto the vase freehand, was adapted from the photographs and Fig. 15 on page 33.
2. The flowers, buds and stems were covered with resist and a coat of apricot lustre applied. The vase was fired at 720°C.
3. The resist was removed, revealing white silhouettes of the lilies and foliage against the apricot background. Shadow shapes were drawn in and surrounded with masking lacquer, and the 'white' lilies and foliage were also covered. Silver-grey lustre was sponged onto the shapes to create positive shadows in the background. After the masking lacquer was removed the vase was fired at 720°C.
4. The lilies and foliage were painted with onglaze colours in two separate applications, each fired to 800°C.

Fig. 6.1 Fuchsias—*17 cm porcelain ball vase*

1. The design was adapted from Figs. 22 and 24 on pages 42-43. The flowers were painted freehand in resist around the shoulder of the vase.
2. Rose lustre, mixed with a little lustre thinner to dilute the colour, was sponged over the surface and the piece fired to 720°C.
3. The vase was brushed over with lustre thinner to wet the surface and carmine lustre, also mixed with thinner, was dribbled down the sides. Full strength carmine lustre was sponged around the neck and shoulder and the vase was fired again to 720°C.
4. The lower part of the vase was once again brushed over with thinner and turquoise lustre dribbled on. Iridescent light blue was sponged around the neck and shoulder. The vase was fired for the third time at 720°C.
5. The resist was cleaned off and the flowers painted with onglaze paint. The paint work needed two applications, each coat fired to 800°C.

Fig. 6.2 Fuchsias—*17 cm six-sided porcelain vase*

1. The design was adapted from Fig. 31 on page 46. The design was made into three panels, each panel occupying two sides of the vase with white bands in between.
2. The flowers and dots were painted freehand onto the surface with resist. When the resist was dry, masking tape was used to form the borders around each panel, then the channels were filled in with resist. (The masking tape helped to keep the line of resist straight. It is tempting to use masking tape to directly mask the border and apply lustre over the tape, but don't—lustre creeps underneath the edge of the tape and leaves an untidy line.) Two coats of black lustre were painted over the surface with a brush, each coat fired to 720°C.
3. To make the black iridescent, mother-of-pearl was brushed over the lustre and the vase fired again.
4. After removing the resist the flowers were detailed with pen work using black china paint. The vase was fired for the last time at 800°C.

Variations
- The resist could be removed before the application of mother-of-pearl.
- The flowers could be penned in using multi-coloured dot work.

Fig. 6.3 Fuchsias—*porcelain jewellery*

1. The design for the 6 cm × 4 cm oval pieces is Fig. 23 on page 42, and the design for the 8 cm × 4 cm teardrop pendant is Fig. 34 on page 46.
2. The three pieces were painted using similar colours and techniques. Resist was used to block out the design, rose lustre applied to the bottom and carmine to the top or side of the shapes. The lustre was fired on at 720°C.
3. One piece was recoated with blue lustre, turning the background violet, and the teardrop pendant had a few dribbles added for variety. Both pieces were refired.
4. After the resist was cleaned off, the pieces were painted with onglaze colours and fired to 800°C.

Fig. 7.1 Agapanthus—*17 cm round porcelain box*

1. The design was adapted from Fig. 42 on page 53, and traced onto the box lid with carbon paper.
2. The positive stem work was masked as well as the negative black areas. Mauve metallic was grounded onto the lid and base and the masking lacquer removed. The box was fired to 830°C.
3. The stem work immediately bordering the black areas was masked, taking care not to apply the masking lacquer over any of the fired metallic. (Masking lacquer is difficult to remove when applied over metallics.) The black areas were grounded, the mask removed and the lid of the box fired to 800°C.
4. Texture coat mixed with glycerine was roughly applied to the stem work. The lid was fired again to 800°C.
5. Platinum was penned around some of the stem work to be left white. Copper metallic mixed with grounding oil and thinned with medium was brushed onto the remaining stem work. The lid was fired for the last time at 800°C.

Fig. 7.2 Agapanthus—*porcelain earrings*

1. Two 5 cm teardrop-shaped porcelain pendants were used to make a pair of earrings from the design in Fig. 43 on page 53.
2. Light blue lustre was sponged onto the two pieces and fired to 720°C.
3. The design was traced onto a small piece of tracing paper and transferred with carbon, reversing the tracing for the second shape. The stamens were not traced on at this stage. Masking laquer was used to block around the design and the remaining area grounded with a blue and mauve metallic. After removing the mask, the earrings were fired to 820°C.
4. The stamens were applied with black enamel mixed to a sloppy consistency with spirits of turpentine. A stylus was used to form the stamens. The earrings were fired for the third and final time to 800°C.

Fig. 8.1 Gold Cymbidium Orchids—*octagonal dinner plate*

The design for this piece is featured in Fig. 50 on page 59. The plate is a piece of Bristile Australian Fine China and has a soft glaze. The first experimental piece of a proposed dinner set, the orchids have been adapted to fit into the corners of the octagonal rim which this set features. The design can easily be enlarged, reduced or distorted to fit onto the other pieces and a simple technique has been chosen to decorate the ware with a minimum of firings.

1. When tracing the same design onto numerous pieces, use a piece of strong tracing paper cut to the shape of the rim and attach

a piece of carbon paper to the back so that the tracing can be quickly repositioned.

Only the flowers were traced onto the rim and covered with masking laquer.

Brushstrokes of Meissen red were applied to the border with a drying Copaiba painting medium, the strokes radiating outwards.

The rim and centre of the plate were cleaned with a rag and the mask peeled off the flowers.

The plate was left to dry overnight, then the orchids were painted in yellow and ochre.

The plate was fired at this stage to 760°C. (Care must be taken not to overfire or place any stilts on this type of ware.)

2. Stems and buds were drawn in and masked with the orchids. Using plastic wrap, black paint was printed over the red rim. The masking lacquer was peeled off and once again the plate left to dry overnight.

The orchids were detailed with red and black pen work and the plate fired for the second and last time to 760°C.

Note A formula for a drying Copaiba painting medium is given in the book *Easy Onglaze Techniques for China Painters and Potters*. This medium remains open for several hours while there is a necessity to work on the piece, but the paint work will eventually dry quite hard, especially when exposed to heat. Open mediums are either non-drying or take too long to dry sufficiently for the additional work needed in these instructions to be carried out.

Fig. 8.2 Gold Cymbidium Orchids—*17 cm porcelain box*

1. The design in Fig. 57 on page 61 was enlarged by photocopying. Transferring was done with carbon and tracing paper.

2. The flowers, bud and stems were covered with resist and the lid and base coated with copper lustre. The box was fired to 720°C. Apply another coat of copper if necessary and refire.

3. The fired resist design was left intact and the negative shapes behind the orchids blocked in with fresh resist.

Turquoise lustre was diluted with lustre thinner at a ratio of 1 part thinner to 2 parts lustre. Using a flat brush, the thinned lustre was applied to the lid and base with cross-hatched brushstrokes. Halos were formed in the drying lustre with drops of dispersing agent. The box was fired to 720°C.

4. The resist was cleaned off, leaving the orchids as white silhouettes with copper negative shapes on an iridescent turquoise/copper lustred background. The colours for the flowers were adapted from the photographs and painted in yellow and ochre with red detailing on the under petals and lip. The lid was fired to 800°C.

5. Additional painting was required for depth of colour and details. To reflect the blue background colour, the petals were shaded with cobalt blue. The fifth and final firing was at 800°C.

Fig. 8.4 Gold Cymbidium Orchids—*18 cm X 12 cm porcelain box*

1. The design features a spike of orchids adapted from the naturalistic drawing of Fig. 44 on page 57. With one exception, exactly the same techniques were used to paint this box as were used for the gold orchid box in the preceding instructions (Fig. 8.2, page 62).

2. Instead of using turquoise lustre over the copper, weeping opal was applied. Weeping opal is a very thin lustre that will run down any sloping surface. The effect on this box was created by applying the opal generously with a large brush and allowing it to 'weep' down the side.

Fig. 8.5 Orchid Pin and Pendant—*porcelain*

1. The designs for the pin and pendant (Figs. 46 and 47 on page 58) were cropped from the original naturalistic drawing which had been reduced by photocopying.

Small designs can be traced onto jewellery pieces if necessary, but because of their miniature size it is generally easier to draw them on freehand.

2. The flowers and leaves were covered with resist and a generous coat of copper lustre applied. Fired at 720°C.

3. Turquoise lustre was brushed over the fired copper and the pieces refired to 720°C.

4. The resist was removed, the orchids and leaves painted in and the piece fired to 800°C.

5. The orchids required additional depth of colour and detail. The leaves were coated with liquid bright gold and the piece fired for the fourth and final time to 800°C.

Fig. 8.6 Orchid Design—*8 cm X 3.5 cm porcelain box*

1. The design used here, Fig. 53 on page 60, has been cropped from the right side of Fig. 51.

2. The orchid was drawn onto the box with a marker pen and covered with resist.

3. Copper lustre was applied with a brush down the right side of the lid, on the base of the box and around the flower, forming the linear pattern. When the lustre was 'just' dry, marbeliser was brushed over part of the design. The box was fired at 720°C.

4. The resist was removed and the orchid painted in with yellows, ochre and red. The box was fired to onglaze temperature, 800°C.

5. A line of platinum was added to the design and the piece fired for the last time at 680°C.

Variation Substitute liquid bright gold, platinum or bronze lustre for the copper.

Fig. 8.7 Diamond-shaped Orchid Pin and Pendant

1. A close-up of one of the orchids (Fig. 55, page 61) has been used for these two diamond-shaped porcelain pieces.
• The pin features a mauve orchid worked using exactly the same lustre techniques as for the pieces in Fig. 8.5.
• The black and gold pendant has been painted as follows:

2. Coat the piece with liquid bright gold and fire to 720°C. Apply an additional coat of gold if necessary and refire.

3. Draw the orchid onto the gold with a marker pen. Using black paint mixed with pen oil, pen in the orchid then paint solid black around the edges. Avoid leaving any smears on the gold. Fire to 780°C.

Fig. 8.8 Gold Orchid Design—*7 cm porcelain box*

1. The design (see Fig. 54, page 61) is a close-up of one orchid cropped from the main drawing. Figure field reversal and an inner frame have been used in the black and white design. A square jewel box was chosen to feature this design in liquid bright gold and the design was carefully transferred to the box lid.

2. A mechanical gold pen (reservoir type) has been used to outline the design in liquid bright gold. The solid areas and wide bands are filled in with a fine brush. On the front and back of the base, in between two solid bands of gold, another orchid is featured. The box was fired to 700°C.

With care this type of gold design work can be finished in one firing; however, hand-applied gold generally requires retouching.

Variations
- The bands of gold could be marbelised.
- Mother-of-pearl could be applied to the white areas of the design.
- Carmine, green or mother-of-pearl lustre could be applied over the fired gold to create iridescent metallic colours.
- Substitute bronze, platinum or copper lustre for the liquid bright gold.

Fig. 9.1 Iris—*4.5 cm porcelain box*

The design for this tiny box was inspired by the small non-objective design in Fig. 65 on page 68. Lustre was brushed onto the lid and base of the box at random using the complementary colours of cinnamon and violet. After firing, other lustre colours were brushed on—carmine, blue and copper—and fired. Finally the design was detailed with metallics and enamel.

Fig. 9.2 Iris—*rectangular porcelain vase*

1. The design, based on the naturalistic drawing in Fig. 60, page 65, was transferred to the china by carbon paper and tracing paper.
2. The subject (positive areas) was masked out with waterbased masking lacquer and the large negative area was grounded in graduated metallics in lemon and dark flesh, top to bottom.
 Other smaller negative areas were sponged in tones of ochre, sepia and raw umber china paint, and the vase was fired at 800°C.
3. The flowers, buds and stems were naturalistically painted with brushed colours as close as possible to the photographs.
 The small negative spaces were again sponged in the same colours, without masking. Firing was again at 800°C.
4. The leaves were masked around and yellow pre-mixed Under Base Acid Look was applied smoothly with a sponge.
 The brushwork was repeated to achieve the depth of colour and tonal value required. Vase was fired at 800°C.
5. Liquid bright gold was applied with a brush to leaves on the Acid Look.
 A small amount of pen work was used to define stems. The firing temperature was 750°C.

Fig. 9.3 Iris—*20 cm porcelain vase*

1. The design for this vase was adapted from one of the photographs on page 64.
2. The flowers and bud were brush-painted in violet lustre and the stems worked in cinnamon and green lustre. The vase was fired at 720°C.
3. Lustre thinner was added to gold lustre and brushed over the entire surface, flowers included, then the vase was fired for the second time at lustre temperature.
4. The vase was once again covered with thinner and thinned violet, blue and orange lustre dribbled to make a pattern. The piece was fired again.

5. The design was then detailed with gold metallic penwork and dribbles. The metallic was fired on at 820°C.

Fig. 10.1 Morning Glory—*30 cm × 19 cm porcelain platter*

1. The design for this platter is featured in Fig. 67 on page 72. The transfer was made by enlarging the design and tracing onto the plate with carbon.
2. The flowers, leaves and stems were covered with resist and a coat of thinned carmine lustre applied with a flat square brush using cross-hatched brush strokes. The tray was fired at 720°C.
3. Again, using a flat brush and cross-hatching, a coat of iridescent light blue was painted over the design and fired.
4. The resist was removed and the flowers and leaves painted with onglaze paint using limited colour. The plate needed three applications of paint, each fired at 800°C.

Fig. 10.2 Morning Glory—*porcelain napkin holder*

1. The design of three flowers was inspired by Fig. 70 on page 73.
2. After tracing the design onto the surface, the flowers were outlined with liquid bright gold, then filled in with solid gold using a small brush. The gold was fired onto the piece at 700°C.
3. The entire right-hand side of the piece was blocked in with gold and when 'just dry to touch' brushed with marbelising solution. When the marbeliser had dried the piece was fired to 700°C.
4. Mother-of-pearl was streaked across the left-hand side of design and onto other parts of the holder. Some of the solid gold areas were retouched and the piece fired for the last time.

Fig. 11.1 Coral Tree—*25 cm bone china platter*

1. The design for this bone china plate was adapted from the naturalistic drawing of coral tree flowers (Fig. 76 on page 77).
2. Only the flower heads were traced onto the plate and surrounded with masking lacquer. Meissen red was sponged onto the design and the mask peeled off. The plate was fired at 760°C.
3. The rim of the plate was painted with radiating brushstrokes of red and the excess paint carefully wiped off the flowers. The plate was fired again to 760°C.
4. After masking the flowers and around the border, black paint was printed with plastic wrap over the red. The mask was peeled off and the design detailed with black pen work. The plate was fired for the last time to 760°C.

Fig. 11.2 Coral Tree—*21 cm porcelain bottle vase*

1. The design was drawn freehand from the original photographs (page 76), adapting where necessary to the shape of the vase.
2. Using onglaze paint, the flowers and stems were brushed in loosely, as well as a pale blue-grey background. The vase was fired at 800°C.
3. Masking lacquer was used to stencil out the flowers, stems and stamens, leaving a band of negative space around them. Black paint was sponged all over to achieve a dramatic effect and the vase fired to 800°C.

APPENDIX—PHOTOGRAPHING FLOWERS

The designs in this book are based on drawings and photographs of live flowers. Always try and draw from life when flowers are available. If possible, first draw them in their natural habitat to capture the plant's character, growth pattern and proportions. Pick the flowers and arrange them naturalistically in the studio if it is not possible to draw them in the garden, but always include the leaves, buds and spent blooms in the arrangement to add character to the design. Take a series of photographs of the plant if you have a suitable camera and use the photos as colour references.

Photography

It's true! Anyone can take a good close-up photograph of a flower with the correct equipment. Most of the photos in this book were taken with two Pentax 35 mm SLR cameras: a Pentax P30 with a Takumar 28–80 mm macro zoom lens and a Pentax Z10 with a 35–80 mm automatic zoom lens and two supplementary close-up lenses, +1 and +2. Both the cameras are fitted with dedicated flash units that automatically adjust to the available light.

Camera buffs will recognise that this is only basic 35 mm SLR equipment and there are certainly more sophisticated cameras available. However, if you are only an amateur photographer, the simpler the camera the better.

Cameras

There are many types of cameras available, the most basic being the inexpensive 'instamatic' compact cameras with pop-up or inbuilt flash units. These cameras are ideal for quick snapshots of the relatives or the scenery, but cannot be used for close-up photography.

The ideal camera is an SLR (single lens reflex) type, which shows you exactly what the camera is about to take before the shutter release button is pressed. Most SLR cameras can be fitted with inexpensive screw-on close-up lenses. A zoom lens is even better, as the focal length can be adjusted to frame up any part of a picture required, either a wide angle view of the subject or a close-up section. For instance, with a zoom lens it is possible to take a photograph of an entire fuchsia plant or of one section of the plant, or to zoom in to photograph a single flower.

The latest SLR cameras are highly automated and very easy to use, as they automatically adjust to the correct light, speed and focus at the press of a button.

Close-up photography

If you have never tried to take flower photographs before, or you are not happy with the photographs you have taken, these few tips may help. They refer to working with an automatic SLR camera with close-up capacities.

- Always make sure the sun is behind you and shining directly onto the flower. Try not to block out any of the light with your body.
- Choose a calm fine day and avoid windy locations. Automatic cameras always select the highest speed possible for the light conditions and adjust the aperture accordingly. In low light situations the subject may become blurred. To photograph moving objects one must use a high shutter speed to freeze movement, and focusing in windy situations is difficult.
- The closer the subject is positioned to the camera the shorter the depth of field becomes. This means that with very close photography only the leading edge of a flower may be in focus, with everything behind out of focus. This happens because automatic cameras are programmed to use the highest speed possible and compensate by opening the lens wider to allow more light in.

 The wider the lens opens (F/3.5 and F/4), the shorter the in-focus range will be.

 The narrower the lens opens (F/22, F/16, F/11), the deeper the in-focus range will be.

 Therefore, if you are taking a close-up photo on full automatic, try for strong light on the subject so that the camera will use a narrow aperture and high speed.

 I often switch my camera to manual and dial a high F stop. (The high F stop number brings more of the subject into focus.) The camera then tells me what speed to set. I rarely take a photo at a speed lower than 1/60th of a second and prefer 1/125th. Camera shake at lower speeds will blur the clarity of the photo.

- In low light situations (where the flowers are in shadow, or perhaps the subject is dark against a light background) consider using the flash unit to brighten the subject. The flash helps to lighten any dark shadows on the subject. The technique is known as 'fill-in flash'.
- Avoid taking white flowers against a dark background in very bright sunlight. Some automatic cameras are lazy and only 'see' the brightest object in front of them; they fail to compensate for darker areas of colour in the composition. The white flowers come out over-exposed and the leaves under-exposed. I try and photograph white flowers in a softer light such as you get later in the day, or with a hazy or light cloud cover.
- A sheet of coloured card is very useful as a backdrop for flowers, especially for blocking out busy backgrounds. If the board is placed close to the back of the flowers, they will case a shadow onto the board, creating interesting shadow shapes which can be incorporated in a design.

 Choose a middle to low value neutral colour, preferably slightly darker than the flower. Under no circumstances back the flowers with white or light coloured board—the camera will automatically 'see' the light board and under-expose the flowers.

 I often use a piece of grey-blue matting board with a white back. In difficult conditions, and with the help of an assistant, the board can be used to shelter the flower from the wind. The white side can be used to reflect extra light onto the subject.

- Do not try to learn everything about a new camera at once; just reading the operating manual can be a daunting task. Keep a tiny notebook and make notes on each photo taken about the subject, the light conditions, whether the photo was taken on automatic or a manual setting and any other detail relevant at the time. Compare the good prints with the bad ones and work out how to improve your techniques by referring to the camera manual or reading simple camera books.

Bibliography

Bradford, Tricia. *A-Z Guide for Porcelain Painters* (1989) Kangaroo Press, Sydney

Brown, S.L. *Textures and Techniques for Porcelain and Ceramics* (1991) Kangaroo Press, Sydney

Preble, Duane and Sara. *Artforms*, Harper and Row

Rawson, P. *Design* (1988) Prentice-Hall Inc., Englewood Cliffs, New Jersey

Tailor, H. *Lustre for China Painters and Potters* (1990) Kangaroo Press, Sydney

Tailor, H. *Easy Onglaze Techniques for China Painters and Potters* (1992) Kangaroo Press, Sydney

INDEX